THE PLEASURES
OF PAINTING
OUTDOORS

WITH

JOHN STOBART

THE PLEASURES OF PAINTING OUTDOORS

WITH

JOHN STOBART

by

John Stobart

WorldScape Productions • BOSTON

*To Sandy, whose dedication
turns dreams into reality.*

Contents

Foreword by Donald Holden

One morning in 1965, I sat on the commuter train to Manhattan, editing the manuscript of an art book. I heard the slightly shy voice of the man who sat next to me: "Are you in the art field?" I had a deadline to meet and I wasn't eager to talk. But I had to be polite: "Yes, I'm an art book and magazine editor." I was hoping to get back to work—and I had no idea that this was going to be an important train ride.

My seat mate said: "I'm an artist."

I said: "That's nice."

"This is my first day in New York," he added hopefully, "and I'm going to look for a gallery to handle my paintings."

Still hoping to escape from a long conversation, I muttered: "I wish you lots of luck."

But I knew I was stuck when he asked: "May I show you my work?" No way out. I nodded.

The artist handed me a looseleaf book of black-and-white photographs, which I opened with a silent groan. But I quickly folded up my manuscript and put it in my attaché case. Even in black-and-white photos, the paintings were extraordinary.

They were paintings of ships and harbors and seaside architecture—and the artist was clearly a master of his subject. First of all, they were magnificent pieces of documentation. I knew nothing at all about ships, but I could see that every detail was absolutely convincing. The artist was obviously a superb scholar and researcher—and a painter of immense skill.

But these haunting images were more than brilliant works of documentation. They were superb paintings. They were filled with magical light and atmosphere. The sea and sky were luminous and transparent. The paintings communicated a wonderful sense of space. They conveyed the sounds and smells of ships, docks, seaside buildings, the sea, and the sea air. They had poetry.

As a painter, I knew that no one can paint such pictures just by collecting old engravings and photographs. I recognized that the artist had gone to nature for inspiration—that he'd spent years standing at an easel, painting on the spot, learning to capture those fast-changing effects of light and atmosphere with broad, rapid brushstrokes. It was the joy and spontaneity of outdoor painting that infused the studio paintings—and made them so memorable.

My seat mate was a master of outdoor painting, as you'll soon discover when you turn the pages of this book. And his name was John Stobart.

I quickly gave him the name of a leading New York gallery. Two years later, John Stobart had his first New York show at that gallery—and it was a sellout. A great career was launched.

DONALD HOLDEN
Irvington, New York
1992

Part One
BECOMING AN ARTIST

1 The Miracle Behind Real Life Observation

To really succeed in any chosen field gives us a wonderful lift to the spirit and a special satisfaction born of the thrills of accomplishment. But after some thirty-five years as an artist I can offer a promise that the activity of painting from nature is not only exciting for artists, but also for their audience, those countless people who have a great fascination and appreciation for masterful works of art. This book, and the video series it describes, is designed to encourage the aspiring artist to take a crack at a tremendously invigorating aspect of painting, that of working directly from nature.

In the not too distant past some of the most celebrated masters pushed man's virtuosity with a brush to a higher dimension by their enthusiasm for painting directly from nature. Corot and the Barbizon School Painters, Constable, Turner, Sargent, Whistler, Van Gogh, Boudin, Jongkind, Monet and most of the impressionists, Sorolla and the more recent masters Chase, Hassam, Wendt, Munnings, and Seago, and a great many more, had all become revered in the eyes of the world for the enormous strides they had made in the skills of the craft, through their spontaneous interpretation of nature, working directly, on the spot.

Not everyone can hope to achieve unusual levels of accomplishment but some will. Most will simply derive intense pleasures from enjoying the environment of the outdoors as they work to create mementos, and experience improvement in the craft.

R. A. Schools life drawing studio. Turner and Constable were pupils here.

Around the time I was graduating from London's Royal Academy Schools in 1957, it was becoming evident that the new vogue of expressive freedoms was beginning to bear influence on art teaching institutions to lessen their emphasis on instructing their students in the basic fundamentals of drawing and painting. It was considered intimidating if not stifling to the new way of thinking then being suggested to the student. With the new ideology being accepted in the majority of art institutions, thirty-five years later it is difficult for many aspiring art students to find traditional teaching, that is, schools which still regard the time-honored disciplines of drawing and painting as the foundation upon which to develop their students' skills. There are fortunately some schools that have retained the former expertise, but they are few.

Within the following chapters I set forth a brief synopsis of the specific steps involved in the process of learning to draw and paint when I went through my own years as a student, just prior to the changes in ideology that began to phase out the basics.

In analyzing my own achievements after becoming inspired to recreate America's wharfside scene in the halcyon days of merchant sail, a subject so rarely attempted by artists of the time, one aspect stands clearly above all others. By far

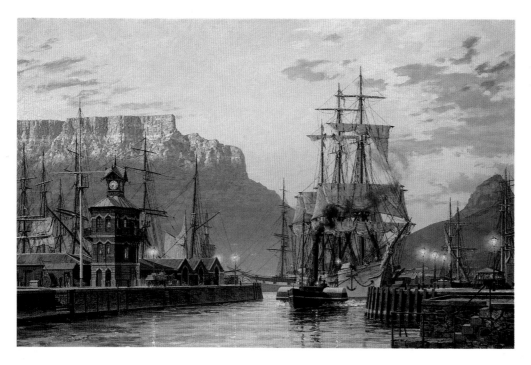

Cape Town. This painting resulted from the dramatic lighting effect I witnessed, arriving by sea at sunrise in 1955.

the greatest factor is the contribution derived from my constant observation of nature's changing moods. Regularly working on the spot to catch a mood or a subtle, or occasionally dramatic lighting effect, and then bringing these back into the studio gives real life to new paintings. Many times these effects have become the very foundation of a major work, and would have been quite impossible to dram up within the confines of the studio.

The miracle behind painting outdoors not only energizes the essence of the artists' function, in drawing out the individuality in their creativity, but as we have learned from many of the revered masters, it also offers the artist a double opportunity. It can be both the crucial means to an end, or an end in itself!

I am not a teacher, and although I enjoy writing, I am not a writer, but having painted all my adult life I have learned during that time that the single most important thing for artists to accomplish is their own "signature," or group of characteristics that reveals their own individual personality in whatever ideology they choose to embrace.

In the field of traditional painting, the origins of this unique quality lie in the way natural things, living things are seen and portrayed. Painting from life is the confrontation between artist and nature where genes and eye and mind together make essential choices of emphasis, where space between, as well as the objects portrayed, are fully realized. Within this exercise lies the one winning card every knowing student has up their sleeve, the nucleus of his or her creativity.

Using the example I am best familiar with, my own development as an artist, I have tried to set out in the following pages the method of working that has brought me substantial success. I will detail a series of practical ideas that surely will not appeal to all. But perhaps in reviewing the seeds of my success and sharing in my work experience, certain new conceptions or new ways of looking at familiar concerns will arouse your inspiration.

4

Having been through an art education system in England, it may be that some of the suggestions I propose will seem unfamiliar, but we all have to develop our own ways of accomplishing our results in order to nourish that important asset of the uniqueness of each of our individual styles.

Surely the whole point of developing your talent is to be certain that your results stand out as different from anyone else. Just as every person in the world has a recognizably different face, your primary purpose should be to ensure that *your* work has characteristics of style that are different from any other, and recognizably so. (See p. 28.)

Let me first retrace the steps of my early years when, as a child, I showed an aptitude, fairly early on, to fiddle about with pencil or crayons. The origins of our initial interest in art are surely buried in our childhood, as are our individuality and our personality. My mother had passed away in giving birth to me and so my father, a highly respected self-made pharmacist and manager of a five-storey emporium known as Boots the Chemists, hired housekeepers to take care of me and my brother. It is these most dedicated ladies that were the ones who championed my cause, by encouraging and nurturing my early tendencies to draw.

As I got older I remember noticing framed watercolors of Derbyshire's Peak District, famed for its Derbyshire Dales, in a small gallery in our city of Derby. These small paintings caught my eye, even as a young boy, as being of exceptional quality. The artist had captured the misty peaks and rolling hills, cows grazing in the valleys and the mood of it all. From that point on my mind seemed to be hooked into looking at paintings, and pondering their merit.

I was brought up, like most other kids, to respect the old adages that were constantly drummed into us. One that seemed to stick in my mind—through practical application more than anything else—was "If a job's worth doing, it's worth doing well." This could be translated, for the self-employed artist more than the leisure artist, into "Every time you work on a painting, give it your absolutely utmost effort, never cut corners."

Inspiration

Perhaps the biggest influence on my own painting career came in 1951 when, as a new student at London's Royal Academy Schools, I took time out to visit the collection of John Constable's outdoor sketches at the Victoria and Albert Museum in South Kensington. I had, of course, by that time seen several of Constable's major paintings such as *The Hay Wain* and *Salisbury Cathedral* either in national museums or in books. In my inexperience then, I had considered such works to be a little old-fashioned or dated in style. But when I walked into the collection of his outdoor sketches I was stunned.

The sight of these works and the virtuosity of brushwork they displayed evoked an emotional reaction in me that was totally unexpected. I think that the reason I was so overwhelmed was that I had been trying my own hand at painting nature with some success. It had already become apparent to me that the course the R. A. Schools offered was a virtual repeat of my four prior years of study in Derby. I had begun to realize that although painting from the nude model was undoubt-

edly the best way to develop painting skills, it was hardly going to be the means by which I could put bread on the table or pay my room and board. It was therefore with the tacit approval of Henry Rushbury, then the Keeper at the Royal Academy, who had gained a national reputation for his Italianate watercolors of cityscapes, that I had ventured out on my trips to the countryside and had noticed how the frequency of these endeavors was beginning to show good results. I was building a familiarity with working outdoors and was enjoying it.

The sight of Constable's work was, however, a total revelation to me. The vivacity of his work, born of the spontaneity of working quickly to capture an effect of light, reveals quite clearly how his paintings were done, brushstroke by brushstroke. They show how it *can* be done. They say to the aspiring artist, "Look! This is possible. This is attainable." In some ways they make it look easy. But above all else they show Constable's choices of emphasis, clearly revealing his strong personal characteristics—his recognizable style. After seeing this collection I felt suddenly stronger, inspired, challenged, motivated, and impatient to dive back into action and hone my own skills.

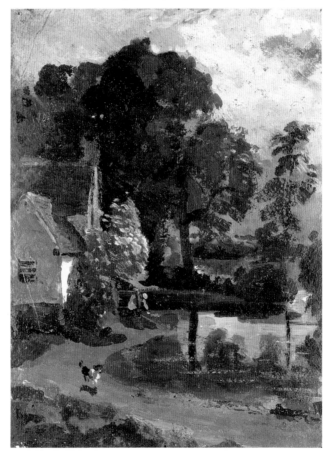

Willy Lott's House Near Flatford Mill by John Constable, oil on paper, 9½" × 7½" (Courtesy of The Victoria and Albert Museum, London).

Although the foregoing was a strong initial influence, it is only one of many that have helped me to shape *my own* ways of working. I also find myself tremendously attracted to Corot's sense of light, particularly in his paintings that feature buildings in a landscape.

It was around 1952 that the Royal Academy filled the galleries of Burlington House with an exhibition of French landscape paintings. The finest examples of works spanning several centuries were brought from all over the world and assembled under one roof. The show was spectacular, and as a student in the Schools housed below I took my time in studying each of the periods in turn, taking my time to pay each proper attention. It was upon walking into the gallery displaying the works of the Barbizon School painters, however, that I was absolutely overwhelmed by a painting of Corot's that gripped my attention even from a distance of twenty-five feet. Titled *View of Villeneuve-les-Avignon*, it reveals the magic of Corot's capacity to create light. It seldom happens,

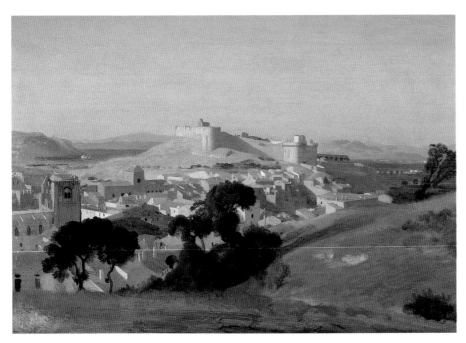

Corot's *View of Villeneuve-les-Avignon*, oil on canvas 15" × 22" (Musée des Beaux-Arts, Reims).

but when I am very deeply struck by a demonstration of unreal ability either in a performance or work of art, or even by a vision in nature, I find that I choke up.

I have also marvelled at the works of other artists, but never to the same degree. Velasquez's *Head of a Servant*, Vermeer's *View of Delft*, Whistler's outdoor sketches. We all have our own favorite artists from whom we derive inspiration, the all-important energy for the soul which enables us to strive harder for our individual goals.

For those who have a compulsion to give it a real try, learning to paint can be an absolutely fascinating pursuit. The rewards in personal fulfillment and for the younger artist especially, self-esteem, can be limitless. Another benefit, perhaps overlooked, is derived from giving pleasure to others. All this is quite apart from the potential your success could have for financial reward. Painting is really all about individual interpretation. Whatever your chosen subject, the principle is to develop your own personal way of creating the illusion of three dimensions in a two dimensional format. To achieve this it will be necessary to understand the importance of first learning basic object drawing and elementary perspective. The vital key to the success of painting is an intuitive knowledge of structure and form, all of which can be self taught by the inspired student. We could say that drawing is the walking, painting is the running. Without the knowledge of the former, learning to paint would be a long, aggravating jog to nowhere.

2 The Learning Process

Being Your Own Coach

For those who don't have the opportunity to enjoy the privilege of being able to attend a college of art and for those who are unable to find a school that has retained traditional values in teaching, it will be necessary for them to follow certain guidelines, passed down over centuries of progress, in order to attain and develop an ability to draw.

I was tremendously fortunate to have a teacher in the college I attended who was dedicated to my advancement. I had failed miserably in high school because I felt no motivation to learn. "Lacks concentration" appeared regularly in the columns of my school reports. The reason was that I always chose the back row of class so that I could spend my boyhood days in the exciting pursuit of drawing World War II airplanes out of sight of the teacher. The result was that I failed all grades, but in the process I had taught myself to draw! In desperation, my father, through his considerable influence in town, and through great presence of mind, was able to get me enrolled in the local college of art.

Derby College of Art's Victorian era building. Note life drawing and painting studios facing north.

The instant I began to attend that college I became totally motivated and to everyone's surprise, not least my father's, progressed rapidly. The course in drawing would last two years. This was two years of continuous practice, first in object drawing, followed by drawing things like chairs and tables. Because the

following two years would involve extensive time painting from the nude model, a great deal of focus was placed on drawing from real skeletons that were rather ungracefully hung up in a cupboard. Our class of five students had endless sessions of learning all about the underlying muscles and then the surface muscles. To further develop our anatomical knowledge before being confronted with live models we drew extensively from the "antique," life-size plaster copies of the world's greatest sculptures: Michaelangelo's *David*, *Venus de Milo*, and others. Our curriculum was rounded off by our being requested to venture out on searches to find and draw buildings from all the periods of architecture evident in our city, from Roman—one of the gates in Derby dates back to the eleventh century—all the way through to Georgian, Victorian, and the architecture of the present day.

Painting studio, inside.

In hindsight I realize that during this two-year course we were not being taught, we were teaching ourselves, through practicing our skills.

I personally don't believe George Bernard Shaw was right when he said "Those who can, do. Those who can't, teach." Our teachers were exceptional and not only had extensive knowledge, but were also impressive painters. Their greatest contribution to us, however, was their total dedication to our progress. They were happy, generous people and guided us through productive, memorable years.

To set the beginner on a similar course only requires some minimal guidance, and sticking to certain rules. The beginning is simplicity itself.

Drawing for the Beginner

For the raw beginner object drawing is a vital first step. The French painter Paul Cezanne, in his considerable wisdom, wrote in a letter to Monsieur Bernard on April 5, 1904 (two years before he died), the following:

"Let me repeat what I told you here, you must recognize in nature the cylinder, the sphere, and the cone, all put into perspective."

When I first read that, I looked out at nature and noticed he was right. He had created the perfect object lesson. But in my view, and for the student who wishes to draw buildings, I would add one more object, though it doesn't appear "in nature," but is seen within it, and that is the cube.

In drawing these basic shapes the beginner will soon need to encounter and master perspective. Again, this begins in a very simple manner with very simple rules.

Perspective is applicable to everything seen. Before progressing to more complicated tasks, the student must gain an understanding of its basic rules. They comprise the very foundation of visualized structures, of creating the illusion of three dimensions in a two-dimensional format. The beginning is easy.

THE CUBE

Cubes should be drawn endlessly. Not necessarily on good paper, scrap paper will do perfectly well for the exercise. The angles from which a cube can be drawn are limitless. The cube is the easiest object to draw in perspective. Extensive practice will make perfect.

In simplifying linear perspective (also see page 111), note that the horizon line is always at eye level. For our illustration there are *two* vanishing points. Sometimes there will be only *one* vanishing point.

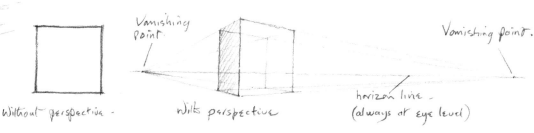

Without perspective -

Vanishing Point.

With perspective

Vanishing point.

horizon line - (always at eye level)

9

THE CONE

The cone is not so easy to set up in perspective. The illustrations will give you an idea as to the cone's structure. Remembering Cezanne's statement, the cedar tree could be considered as nature's perfect cone.

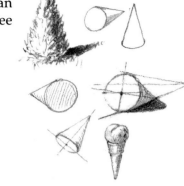

Without perspective

In perspective.

THE CYLINDER OR CAN

Drawing this shape again will involve elementary perspective as shown. It will also involve testing your ability to draw an ellipse, which is an elongated circle.

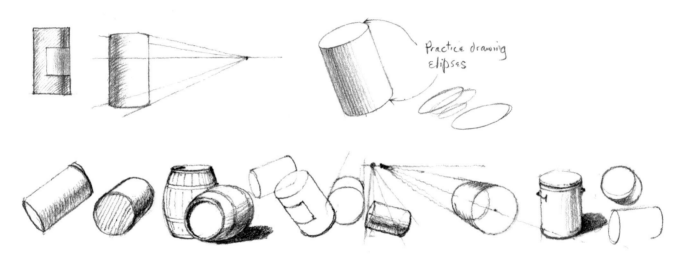

Practice drawing elipses

THE SPHERE

The sphere is, again, difficult to set up in perspective unless it is placed in a box. The sphere is always round, whichever angle it is seen from. Shading as I have shown will give the effect of solidity.

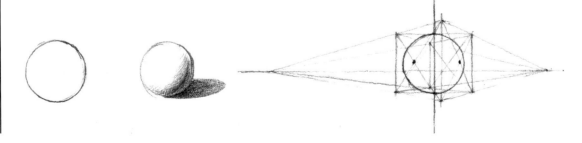

All these objects should be practiced endlessly until a familiarity, an intuitive knowledge of how to structure them from any given viewpoint, is accomplished. All these shapes can be recognized, for instance, in my view looking down a street. For this example, I use *parallel* perspective (see page 111, number 3.), one vanishing point for all structures in this scene.

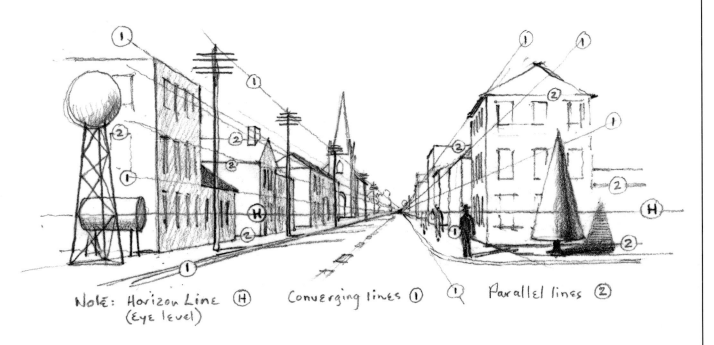

Note: Horizon Line (H) Converging lines (1) (1) Parallel lines (2)
(Eye level)

Look around you and see how other objects fit into Cezanne's idiom, that all things in nature are, in whole or in part, a combination of basic shapes.

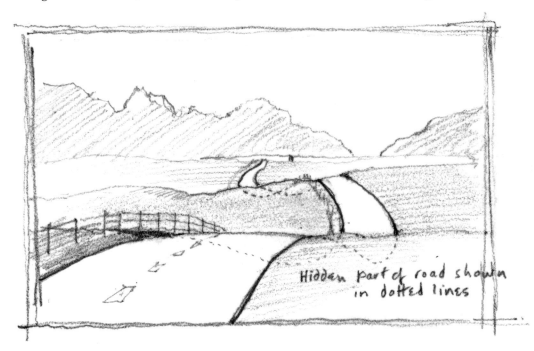

Hidden part of road shown in dotted lines

For those who enjoy drawing figures, they too are an extension of the basic shapes as are animals and birds, mountains, airplanes, ships, and even clouds. Let's see how the face reveals the importance of perspective in its structure.

Lastly, we'll look at a few other simple drawing samples. A road going into the distance over ranges of hills (see page 11). A house on a hill. A ship at a dock.

Drawing is the basis of all fine painting. That is, the ability to set up anything seen in order that it appears structurally correct and does not appear distorted. *Practicing* drawing regularly is the only way for the beginner to master its variety of factors. By far the best method of learning to draw is to draw actual things *from life* and *not* to copy reproductions or photographs. The mastery of this craft will come best and quickest only through drawing actual things in front of you.

I well remember drawing portrait heads at every opportunity, even of friends or colleagues at school. Your progress will

12

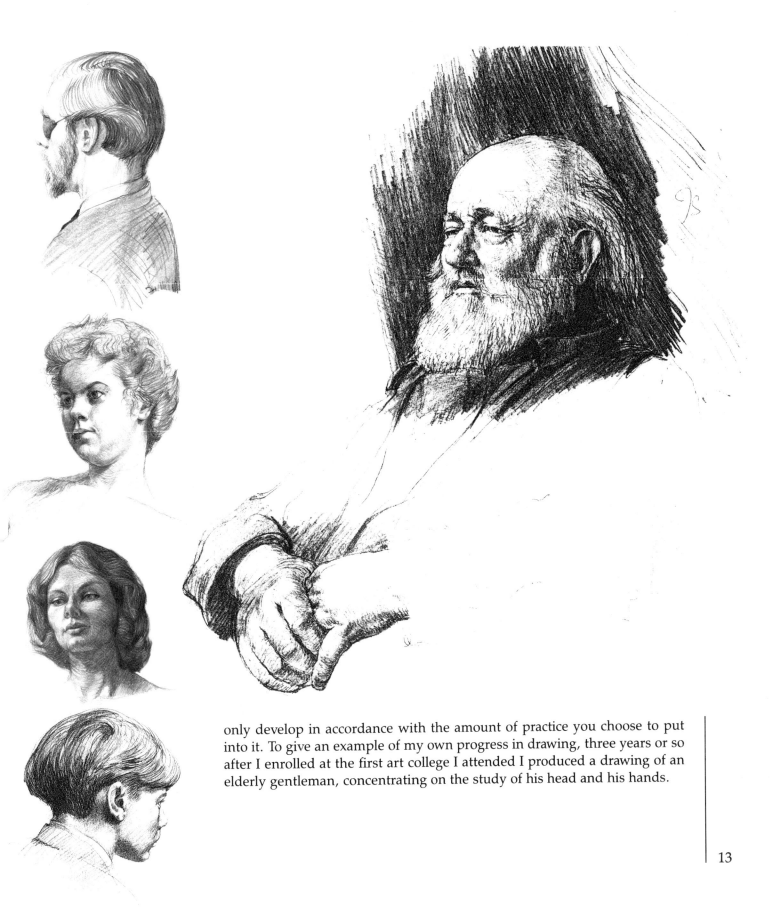

only develop in accordance with the amount of practice you choose to put into it. To give an example of my own progress in drawing, three years or so after I enrolled at the first art college I attended I produced a drawing of an elderly gentleman, concentrating on the study of his head and his hands.

3 Painting

Methods and Materials

Before you take your first steps in painting you will need to consider a myriad of alternative mediums and surfaces to paint on, brushes, and colors.

In this book I discuss oil painting on canvas as that is my familiarity. When I began painting at art school there was no alternative. Teaching different techniques and mediums would have involved widened facilities and a larger staff. Today, however, the choice of methods and materials is endless.

Firstly your surface, be it paper, canvas, panel, masonite, canvas board, or illustration board. Then there are choices of medium. Watercolor, gouache, pastel, acrylic, oil, or tempera. There is a variety of available brushes to fit every imaginable requirement and finally, the choice of over a hundred pigments or special colors, even though they all emanate from the primaries: red, yellow, and blue!

My purpose here, however, is to suggest that simplifying the whole process will work to your advantage, make it easier for you to make a start and eliminate some pitfalls. My own expertise is in painting in oil on canvas in the same time-honored fashion

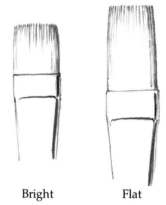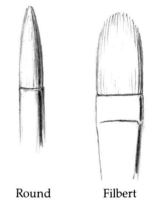

Bright Flat Round Filbert

The four commonly used bristle oil brushes.

that the great masters perfected. It is their invaluable legacy that has been handed down, over the centuries, all the way to our generation. In my view this medium has greater flexibility, convenient workability (doesn't dry fast), more options for painterly characteristics, greater longevity, and the potential for greater value appreciation than the other options can offer. For our purpose of painting outdoors I will therefore concentrate on the preparations necessary for working in oil on canvas.

Choosing Your Format and Stretching Canvas

Back in the old days money was short so we had to acquire our canvases as best we could. There was an old flour mill in Derby that threw out used flour bags made of fine burlap. The trouble was they were stamped with the mill's name in red dye and the trick was to find bags that had been stamped on one side only.

In any event, this was our saving grace. We fashioned our own stretchers out of wood thrown away on building sites. In stretching those canvases, however, if there was any of the red dye on the portion we'd primed, the dye would soon

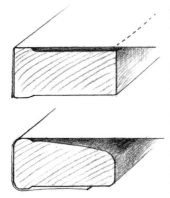

Changed section of commonly available stretcher after bench work eliminates disadvantages. Note: sharp edges, top, with location of future cracking (dotted line).

1

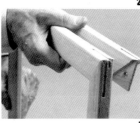

2

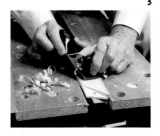

3

bleed through right into our painting, which would then have to be thrown away. That was all fun then, but I'm glad those particular problems are long gone.

For the purpose of working outdoors, I purchase the commonly available stretcher pieces in a variety of small formats. Most paintings discussed in the following chapters are either 12″ × 16″ or 12″ × 18″. One is 9″ × 12″.

It is wise to work on a small format when painting on-site, simply because you have limited time to accomplish your result. It is also helpful if all the gear you are carrying can fit into one bag. I like all canvases I am carrying to fit within a 12″ × 18″ dimension. Ideally, I will carry an 8″ × 12″ as well as a 9″ × 12″ as they conveniently fit into the 12″ × 18″ space. All the canvases can therefore be placed close together in the bag with little or no chance of damage.

Another option that I have developed to suit my own needs and to save space is to mount several canvases on a piece of luan plywood cut to the size I like to work in. In this case I can mount at least four prepared pieces of canvas on one piece of plywood, one on top of the other, secured at the back with packing tape. Now I have four canvases, ready to paint on, well secured on the plywood, taking less than the space of a single canvas on a stretcher! This is an excellent method if you contemplate doing many paintings, on a trip to somewhere like Venice where you might want to be prepared to produce many works. All works can be reattached to the plywood for the trip home where each can then be individually stretched on its own stretcher (see page 22, number 3).

As you will read in the chapter on the Beer subject, our guest artist Trevor Chamberlain nearly always works on the spot with a Pochade box and a format of only 7″ × 10″. The Pochade box is especially useful in bad weather as it can be placed in your lap as you sit working from the comfort of your car seat! But as designed, its usefulness is that it can be hand-held, and holds all necessary lightweight materials for a quick sketch.

Before stretching our canvas, we need to look at the stretcher itself. For the amateur or the person painting for pure leisure, the store-bought stretched canvas, trimmed off at the back edge will work perfectly well.

I would strongly recommend to the serious student, however, and the painter who is looking beyond to a possible career as an artist, that they consider some disadvantages of the commonly available stretcher. Many of them have sharp edges where the canvas is pulled tightly to the sides. There is a tendency here for the ground to crack along this edge. Also, should you wish to retain the option of restretching your canvas for the purpose of altering the balance of your composition, this sharp edge and the permanent crease it has made will pose further difficulties.

Another major disadvantage is that the inner edge of the stretcher pieces are too near the canvas when stretched (1). One will often see in museums and galleries evidence of a crack some 1½″ in from all edges of some paintings. This is because of the close proximity to the canvas of the stretcher's inner edge.

To remedy all these factors I always spend five or ten minutes on the bench to adjust the profile of each stretcher piece. First, I round both outer edges of each piece (2), and second, I plane down the inner surface in order that it is bevelled back far enough so as to avoid any possible contact with the stretched canvas at that point (3). The stretcher is then ready to assemble.

In assembling the stretcher, I always have at hand several sizes of triangular pieces of luan plywood in order to be fully prepared to stretch any given size of canvas. First, I roughly assemble the stretcher pieces into their rectangle, then am sure to carefully check six measurements. Top to bottom left and right, side to side top and bottom, and most important, both diagonals. Having established that the stretcher has ninety degree corners and is true, I temporarily attach the plywood triangle to the back on one corner with 1″ brads (4), then place a temporary brad in each of the other corners. This precaution will absolutely ensure that the stretcher will not go out of square as I apply the canvas. This process is second nature to me now, and a necessary evil.

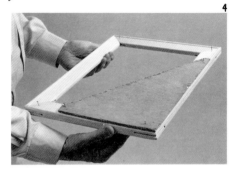
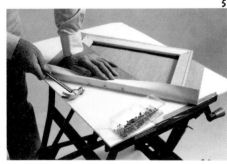

I then cut a piece of canvas, usually off a 52″ roll, being sure to allow 2″ extra to the size of the stretcher on each side.

Using ⅜″ copper tacks I then attach the canvas to the face side of the stretcher, confident that with the brads in place it will not budge at the corners by slipping diagonally. Be sure that the grain of the canvas is parallel to the stretcher's sides while stretching. Beginning with three tacks (5) in the middle of one side, about 1½″ apart, I then pull the canvas to the opposite side, securing it there with one tack. I then pull the canvas, not too taut, to one end, securing it with one tack in the middle, then pull tightly to the remaining end, again securing with one tack (6). This is followed by methodically pulling toward the corners from the middle of the stretched canvas inserting tacks every 1½″, securing it up to the corners. In finishing off I tidy up the corners with double folds (7) before standing back to admire my effort!

In using copper tacks, I make sure that they are left proud until I am absolutely satisfied with the eventual painting. Copper tacks will not rust over time as will the normal staples that are used in some cases. With the stretcher edges nicely rounded off, I can now be sure that should I desire to restretch the canvas and gain up to half an inch in the process I will be able to do so without a crack appearing inside the edge of the painting. With this system I have also ensured that there is plenty of spare canvas behind each side for such restretching contingencies.

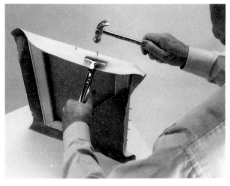

Use of canvas pliers increases leverage and tension.

Note in mirror reflection how I gained ½" for extra sky by restretching the Maui canvas. This would not be possible without spare canvas at back.

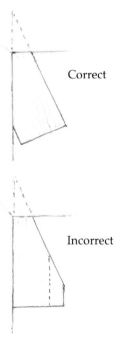

Correct

Incorrect

Insertion of keys. Likelihood of splitting along dotted line.

Additional Priming

The experience of over thirty-five years has taught me to take even further precautions to avoid trouble later on. In the past I have had letters from the collectors of my originals complaining about circular cracking within the painting's surface. This is because the painting has been unknowingly or carelessly leaned against a pointed object. The high likelihood is that this happened while the picture was in the custody of the owner, but the artist is often assumed to be at fault.

To prevent this from happening I take two further precautions. I use acrylic-primed canvas instead of oil-primed canvas. When I first adopted this idea I called Ralph Mayer, noted authority on methods and materials, at his home in New York City, just to make sure that the bond with the oil would be permanent. In the twenty-five years since then I have not had a single call about circular cracking or any other adverse contingency relating to the ground. I also always back my completed canvases with a foam-core backing prior to framing (8).

Before painting I apply three more coats of acrylic gesso to the canvas surface, sanding it first to ensure a good bond, new with old. To lessen the canvas "tooth" I apply these additional coats with a credit card (9), making sure to eliminate all ridges, wiping off excess at the rounded edges to prevent extra buildup in case I have to restretch later.

Finally, prior to painting, I apply a thin turpentine wash of burnt sienna to tint the canvas with a warm beige, then my canvas is ready for action.

8

9

Choosing Your Palette

The selection of colors you will need to make from all those available to take with you on your painting trip is referred to as your palette. Confusingly, so is the wooden board with a thumb hole in it that you will use to mix colors as you paint.

Right from the outset of my education I have only used five colors. We were advised at that early stage that to use a restricted palette would help ensure a harmony throughout our work. This seemed logical enough at the time and has certainly worked for me ever since. So out of the tremendous range available I use cadmium yellow, Winsor red, French ultramarine, permanent green and burnt sienna. I will try to show the range of colors this can achieve, though in reproduction the colors may not seem as vivid as in the palette illustration.

As to white, I use titanium white due to its strong covering power. Years ago I used flake white but thereby hangs a tale.

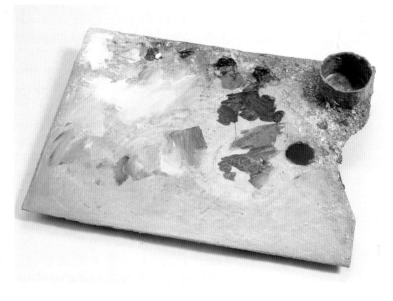

The five colors on my studio palette.

I had produced a large painting of a new ocean liner named *Reina Del Mar* leaving Liverpool on her maiden voyage. The painting was done on spec and when complete I took it along to its owners, the Pacific Steam Navigation Company, to see what interest I could arouse. The date was around 1958. Well, they were duly impressed but announced, to my absolute astonishment, that their ship had that very morning been sold to a foreign company!

Hardly had I heard these words, it seemed, than I was back at my makeshift studio in Earls Court, an inner suburb of London, removing this fine ship off the canvas with my circular sander, with weeks of painstaking effort dropping as fine white dust into the studio's rug. As I went about this task I was most careful to leave intact the important setting of Liverpool's majestic waterfront buildings that were to the left in the large 30″ × 50″ canvas.

On the same day that I had witnessed the maiden voyage departure of the now deleted vessel, another ocean liner was at Liverpool's famed Pierhead. It was Elder Dempster Line's sleek flagship *Aureol*, a more graceful vessel by far than the former ship, and one that I felt would be thrilling to paint in as a replacement. Elder Dempster not only purchased this speculative work, but the venture resulted in their commissioning me to paint nearly all the new ships they brought into service over the next fifteen years.

It was some two years after I had delivered the large original, almost to the hour, that I was to receive a very upsetting telephone call from the company's head office.

"Mr. Stobart." I instantly recognized the deep voice of their public relations director as he went on, "The painting of *Aureol* you did for us." "Yes," I replied

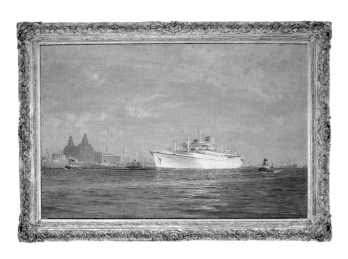

Elder Dempster Lines flagship *Aureol* leaving Liverpool.

questioningly, curious to know what this could possibly be about. "Well, it's very strange," he continued, "but there seems to be another name appearing below the name *Aureol* on the vessel's bow. We wonder if there is anything you could possibly do about this?"

In my haste to lose no time in the former conversion process, I had apparently neglected to sand off the vessel's name *Riena Del Mar*, but instead had simply painted over it.

Almost mortally stunned with embarrassment, as I had not wished the company to know that their ship had replaced another, I assured the P.R. director that I would immediately come to their Liverpool head office and rectify the mysterious phenomenon.

Eventually I plucked up enough courage to make my confession as to what really had happened. The directors seemed to actually enjoy the story, which, whenever I was in their company on subsequent occasions, would always draw hearty guffaws.

The reason I mention this story is that it touches on several key issues. In the first place it resulted in my making two immediate changes in my procedures. I never again used flake white, switching instead to titanium white, which has greater covering power—a pigment's ability to obliterate or permanently cover up the color under it. The other thing the experience taught me was that lighter tones can have a tendency to grow translucent over a period of time. It is a good idea therefore to *always* remove dark underpaint if it is eventually to be replaced or overpainted by lighter tones.

In my own case I have perfected a system of removing *dried* darker paint with a flexible razor blade. Bending it between thumb and forefingers, I very carefully shave off the offending darker paint until I have reached the ground white. The same result can be achieved with sandpaper—fairly rough—by dipping a small piece in turpentine and using a circular motion to gradually erase the underlying dark paint. Those who want to attempt the razor technique, *please* practice this first on a discarded canvas to perfect your skill. We would not want any razor cuts to penetrate the canvas that would, of course, ruin it. This is a system I have developed over a long period of time. The result is that the lowly flexible blade is one of the most important tools in my paint box! The same lesson, proving the gradual translucency of thin lighter paint coatings, can be learned by looking at some of the old masters' paintings, where later alterations of light over dark have become apparent to the viewer.

Secondly, it brings up the importance of communication and the artist's absolute responsibility to happily guarantee satisfaction, even though this might mean bothersome after-sales service. Building confidence in the people who purchase your originals will result in their becoming your personal ambassadors to the world where being thought of as a person of high integrity can only bring you rewards in the future.

I am absolutely confident that the five colors in my palette will more than

adequately produce any hue or tone seen in nature. The thirteen paintings in the following chapters will to some extent reveal this. They may also reveal that by keeping the colors of your palette to a minimum there is greater potential for overall harmony in your work. This brings up another experience I encountered quite recently.

This story begins with my strong desire to portray the nineteenth-century whaling station at Lahaina, Maui, in the Hawaiian Islands (see illustration page 93). I had never been to Maui but had previously stopped off in Honolulu en route to the Orient, and while there had marvelled at incredible vertical cliffs on the back side of the island that seemed, for all the world, as though they had been newly carpeted with emerald green rugs! I simply could hardly believe their vivid color.

Prior to leaving for Maui, I therefore consulted a couple of the artists in the small fraternity of advisers I like to empathize with occasionally, asking them which stronger, more vivid pigments I should take along to achieve the phenomenal greens of Hawaii's peaks, and two were duly suggested. When I went along to purchase these, however, I was somewhat taken aback to discover that both were in the $35.00 per tube range and balked at this seeming extravagance. However, I gritted my teeth, deciding to "go for broke" to be absolutely certain I would be prepared to properly accomplish the Hawaiian challenge and purchased both.

Well, in producing the painting I very soon discovered that the greens I had acquired, vivid though I had imagined the mountains to be, were totally unnecessary and that my customary permanent green, together with cadmium yellow had the power of producing far more vivid color than I needed to accomplish the right effect of the distant mountains! I have since been looking for a fellow artist whom I could present these two colors to as a memento of this silly experience.

I specially like the various softer sky colors (I always go light on skies) that French ultramarine and permanent green with cadmium yellow and Winsor red can offer and even in this field of ethereal colors I have never felt the necessity to augment my simple selection.

Black is missing from my palette intentionally as years ago when I did use it, it seemed to get into everything and kill the purity of the other pigments I use. With burnt sienna and French ultramarine, combined in various ways, I can get a wide range of blacks, from cool to warm, each of which will better harmonize with all other aspects of my subjects. I feel that there is no black before you, when painting outdoors, that is blacker in appearance than the blacks I can get with this combination.

Preparing for Your Outdoor Mission

Being totally prepared at all times is an important prerequisite for the outdoor painter. After all, you never know when inspiration is going to strike, or the weather will suddenly play into your hands and deliver just the right sky or sense of light you've been waiting for to catch a particular subject at the right moment.

The ideal way to be prepared is to have all your painting gear in one bag. This is no easy accomplishment at first. It has taken me some twenty-five years to hone the process to the point where I feel I've now got it down pat, although I should

take into account the fact that over some fifteen years I neglected to maintain painting outdoors until colleagues, some six years ago, reminded me of its therapeutic benefits and got me out again. What seems to happen is that over the years, as you meet other artists and discover their ways of doing things, you accumulate all the best ideas and finally build a familiarity with working in a certain way.

One of the best tips I got was soon after I had emigrated to the United States in 1970. I had the pleasure of meeting a landscape painter, the late Bob Lougheed, who then lived in Wilton, Connecticut. He introduced me to a group of artists working in and around Westport, Connecticut, and we all got together for dinner on the last Thursday of each month. The next thing that happened was that I was invited to exhibit at the National Cowboy Hall of Fame, a gala event put on by the National Academy of Western Art. Just what I, as a maritime painter, was doing at such a show almost defies explanation, but the event was thrilling in many respects and one of their special features was a demonstration by a group of artists who set up their gear and painted their choice of subject as the assembled guests watched their progress.

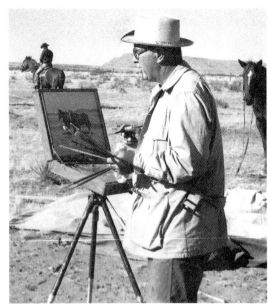

My late friend Robert Lougheed demonstrating at the National Cowboy Hall of Fame, Oklahoma City, using his tripod setup.

One thing about the event stuck in my mind more than anything else. It seemed that Bob Lougheed had his gear set up in an instant and was almost through with his demonstration while the other participants were still assembling gear from their cars! Bob's secret was that he had a small metal plate bolted to the underside of his paintbox, in the middle of which was a hole with a camera tripod thread. All he had to do was to bring the tripod and his box from his car, screw the box onto the tripod, and immediately commence work. Everything he needed was in that paintbox!

Although I prefer to sit down to paint, utilizing this method was a big step forward for me and substantially reduced the weight of the gear I customarily carried around. I recall two recent trips to Venice that involved enjoyable but sometimes exhaustive walking around before the right subject caught me. It has always been an important consideration therefore to be conscious of the weight of my assembled materials and to keep this down to a bare minimum.

I have a black bag into which everything I need fits perfectly. For extra protection on airplane flights I have a leather suitcase into which the black bag fits snugly and also has room for additional canvases I might need during a long trip.

Before describing the items in my paint box let us first empty the black bag and go over its check list. (See illustration next page.)

1. One of two seats, this one with wooden legs and a thick

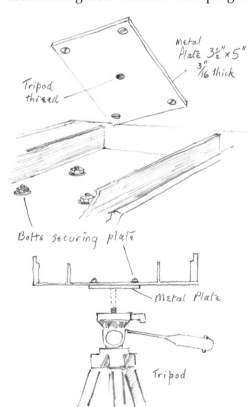

Metal plate with camera tripod thread in center, as attached to paint box.

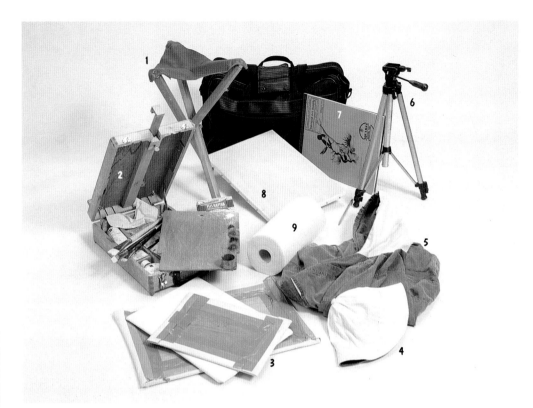

All the contents of my outdoor painting bag.

leather top. (The alternative, shown in the margin sketch, is a folding metal seat that exactly fits the bag, with a nylon top.)

2. My paint box, which doubles as an easel and can hold canvases up to twenty-four inches deep.

3. Three of four luan plywood boards I carry, each with four pieces of prepared canvas attached to them, pulled taut and taped at the back. The potential here is for sixteen outdoor paintings that can be reassembled on the luan boards when dry for the trip home. Each can later be mounted on their own individual stretchers.

4. My white cotton hat for sun protection.

5. A hooded jacket. An essential item in your equipment. Nothing can be more discomforting than a steady breeze at the back of your head when working.

6. A camera tripod, adjustable to cope with any slopes or difficult terrain.

7. Sketch pad and pencil for making vital sketches with notes in case you have to leave before you have completed work. Completing an outdoor painting from your own sketches and written observations does not bear the detrimental consequences of referring to a photograph.

8. A stretched canvas, prepared for use.

9. The vital necessity, a roll of "two-ply" paper towels, showing the "dispenser" for used towels in its center!
(Not shown here, but safely secured in the bag is a small bottle of throat spray and a container of vitamin C tablets. If my resistance is lowered by cold weather, the last thing I need is to catch a cold. This is my own proven method of preventing that.)

Alternative steel frame seat fits bag perfectly and also helps protect contents.

Now we'll examine the contents of the paint box itself, listing all items as they are assembled in the illustration.

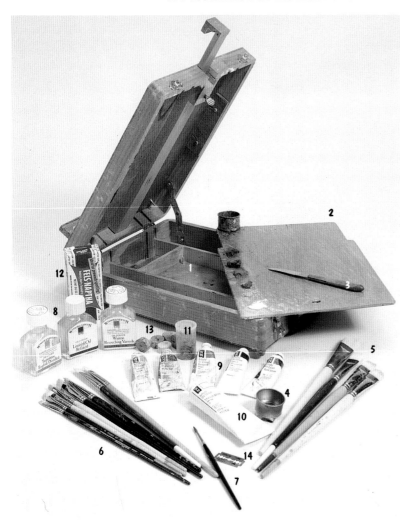

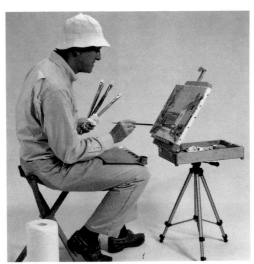

Paint box and contents.

1. The box itself. Note the metal plate inside, attached by four bolts at its corners, a camera tripod thread in its center. In this particular case the plate is *inside* the box. In fact it is better for the plate to be *outside* the box as the bolts at the top of some tripods are so short that they are not long enough to reach through the plywood of the box as well as further into the metal plate.

2. The palette, thin plywood that fits the box perfectly. I rest this on my knees while working, therefore I do not need a thumb hole.

3. A palette knife.

4. A medium holder.

5. A selection of four wide bright brushes.

6. A selection of smaller bright brushes.

7. A No. 5 pure sable brush.

8. Jars of pure turpentine, linseed oil, and retouching varnish.

9. Five colors: cadmium yellow, Winsor red, permanent green, French ultramarine, and burnt sienna.

10. Titanium white.

11. A plastic container of copper tacks, and 1″ brads.

12. The most essential Fels Naptha bar soap for washing brushes in hot water as soon after use as possible.

13. Six cork segments, cut approximately ⅜″ thick for attaching to canvas corners to protect wet painting by covering and securing with same sized board.

14. Double edged flexible razor blade.

15. Hidden in the box, out of sight, the combination hammer/screwdriver set shown being used in illustration on page 17, together with canvas pliers.

The foregoing items have sufficed for all the paintings I have produced both inside and outside the studio over the past thirty years. I should only add that it is a good idea to have a check list actually *attached* to the inside of both your box and your carrying bag as one item forgotten on a long trip can cause considerable aggravation, as you may be unable to replace it where you are going.

Composition, Bold and Simple

Knowledge about this subject can only come through your own observation and practice, building your intuition over a period of time.

We can simplify this by noticing that all things seen have shapes, either grouped together as clumps or as separate items. Let us invent a dreamed-up composition for the purpose of explaining its merits. It is made up of silhouettes, which overlap, and a focal point to which we wish to direct the attention of the viewers' eyes so as to retain their interest, and not have them wandering off quickly to someone else's painting that hangs next to yours.

A clump of trees to the left makes a large, major silhouette (1). The road (2) takes the viewer's eye from the lower left, leading it around the edge of the trees and into the distance where the focus of the painting shows mountains on the horizon (3). The telephone pole (4) achieves the objective of tying all segments of the composition together and actually assists in creating a feeling of recession. The pole could be considered analogous to a ladder in the game of snakes and ladders. In our case the viewer's eye can go up the pole from the fence and grassy verge (5), and get off at the middle distant trees (6), the mountains (7), the blue sky (8), or the cloud (9), and relate to each.

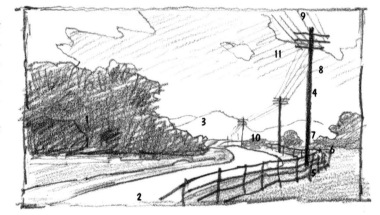

The telephone wires, again, direct the eye to the focal point, as does the fence that also serves the important function of preventing the viewer's eye from wandering off our scene to the right by curving it back (10) to our focal point (3). The viewer's eye is therefore contained within the composition by the perspective lines of the road, fence, poles, and wires all leading to the focal point.

The upper top right cloud (11), has a lower edge that prevents the eye from escaping out through that corner, as does the cloud at the top left which, in disappearing behind the clump of trees, also creates depth.

To conclude, a *spatial* effect can easily be achieved by the use of aerial perspective, making the tones of each overlapping silhouette (dark or light) graduate as they recede to the far distant gray.

Likewise, in respect to color, the rich, stronger hues of the foreground will lessen in their respective intensity all the way to a light warm gray in the distance, the bright, near clouds getting slightly warmer and darker as they recede through all the atmosphere between, into the same distant warm gray.

In producing retrospective maritime studio paintings, I enjoy playing around

with countless compositional ideas, drawing on scraps of paper, often on airplane flights, searching endlessly for a winning idea by drawing quick thumb-nail (1½″ × 2″) conceptual sketches until I hit on something worthy of developing. In working outdoors, however, you have to be constantly aware of compositional factors, honing your ability to recognize a pleasing effect that is nicely framed by the natural elements before you.

Making a Start

For the beginner, there is simply no better solution than to go out, set up, and pretend to be the master you're not! Play with the paint, get used to its qualities, experiment with big brushes, ¾″ would be ideal. Try painting big silhouettes of color, radically simplifying what you see before you. Your first efforts will be discouraging, but that effort will mark a milestone in your life.

Most beginners get stuck with playing around with little brushes, trying to "finish" little pieces of a scene. Others will find the big white canvas threatening! Let us enjoy the words of one of the world's all time great leaders, Winston Churchill, as he faced his first canvas:

"Having bought the colors, an easel, and a canvas, the next step was *to begin*. But what a step to take! The palette gleamed with beads of color; fair and white rose the canvas; the empty brush poised, heavy with destiny, irresolute in the air. My hand seemed arrested by a silent veto. The sky . . . was pale blue. There seemed no doubt that blue mixed with white should be put on the top part of the canvas. One really does not need to have an artist's training to see that. It is a starting point open to all. So very gingerly I mixed a little blue paint on the palette with a very small brush, and then with infinite precaution made a mark about as big as a bean upon the affronted snow-white shield. It was a challenge, a deliberate challenge; but so subdued, so halting, indeed so cataleptic, that it deserved no response. At that moment the loud approaching sound of a motor-car was heard in the drive. From this chariot there stepped swiftly and lightly none other than the gifted wife of Sir John Lavery. 'Painting! But what are you hesitating about? Let me have a brush—the big one.' Splash into the turpentine, wallop into the blue and white, frantic flourish on the palette—clean no longer—and then several large, fierce strokes and slashes of blue on the absolutely cowering canvas. Anyone could see that it could not hit back. No evil fate avenged the jaunty violence. The canvas grinned in helplessness before me. The spell was broken. The sickly inhibitions rolled away. I seized the largest brush and fell upon my victim with berserk fury. I have never felt any awe of a canvas since."

Churchill's avocation, taken up around the age of forty, gave him untold pleasure throughout the rest of his life, and is a wonderful testament for those who might fancy taking up painting as a hobby. Like the life he lived, his book, *Painting as a Pastime*, is a classic and a wonderful incentive to give painting a try. "Try it if you have not done so," he urges, "before you die."

I discovered that the best way to begin is to establish the parameters of the scene or subject I am attracted to by deciding on, then sketching in the salient points of my composition with thin paint. Paint that can be readily absorbed by subsequently applied thicker paint.

This is where your drawing ability will pay off. The ability to first master *drawing* is suddenly revealed to be essential. At first you should try the simplest possible subject or scene. Trying a complex subject at the beginning can only increase the sense of discouragement that is almost unavoidable at the outset.

In choosing to discuss my own approach to making a start, you should first realize that each and every artist should develop *their own* method. One, for instance, which is extremely effective, is to swish in some color in this sketching stage that would be left as is, eventually becoming in itself the spontaneously applied finished effect, revealing a mixture of texture, dry brushwork, turpentine wash, and almost accidental strokes to enhance an effect of snow, sand, sunlight, or water. This would be the exact opposite to the detrimental effects of overworking your painting.

The next step I take is to simply block in the major color shapes—blue sky, dark building, tree trunk, roadway, water. This should be done with a ¾″ brush. If you are working on a small format as I have suggested, this process can be achieved quickly. The trick is to be sure to draw in the shapes with your brush as accurately as possible, using the edge of your brush to correctly define the major shapes before you.

We all make mistakes at this point. It is part and parcel of the essential trial-and-error process. You will then correct your mistakes as you proceed. It is here that you will encounter your first difficulties, in redefining your painted areas and at the same time keeping the color clean where one color meets another. This is where your motivation will be challenged. The only thing I can promise is that with perseverance, for those so inspired, just as practicing the piano reaps noticeable results fairly quickly, you will soon be able to compare your fourth work with your first and will begin to notice your improvement.

Many times I have disliked a start on a painting to such a degree that I have scraped the whole thing off with a palette knife. Strangely, this gives you strength to start again on a surface that now better accepts the new paint! If you want to follow my own suggestion, be sure to use very little oil in your medium so that, as the turpentine evaporates, the block-in paint will gradually become more tacky and workable.

As you work, use plenty of paper towels and always clean your brush as you change from color to color, tone to tone. I tend to use only one brush, cleaning it regularly at this stage of the painting. Others use two or more—one maybe for dark areas and another for light areas, but the presently available paper towels (two ply) are a miracle come true for today's artist. A clean paper towel, wrapped round your index finger will also allow you to redraw areas, removing first paint mistakes. As each paper towel becomes clogged with paint as you constantly clean your brush, a good tip is to simply push them, one after the other, into the cardboard tube the roll of paper is wrapped around. This prevents them scattering around in the breeze and avoids their getting into contact with the rest of your gear.

Getting started should not be taken too seriously at first but should rather fall within the realm of experimentation, with less regard for a finished product than for feeling your way in the simple handling of paint. You have to understand that you cannot possibly hope to accomplish your goals without enduring the learning

curve. As you proceed, however, you will experience moments of delight as you impress yourself with unexpectedly pleasing effects!

In my own case it was some four months after I had begun painting in earnest before I suddenly realized I'd got it. Somehow my palette was all mud. I used black at first and it got into everything. We also used paint rags which were scarce and got terribly overloaded and messy. I really don't think it need take four months for everyone. I was being taught then by someone our class of five absolutely adored but he was not a full time practicing artist, he was more of a part time surrealist. His finesse was not in getting a painting down in two hours outdoors. Had it been, I'm certain that my progress would have been quicker, with a sense of accomplishment being built earlier.

Creating Your Own Steps

I have never been specially helped by seeing step by step pictures in books. I think every artist needs to adopt a process that suits their own individuality. Some artists like to complete areas of their paintings before the whole is blocked in. On the other hand, I prefer to block everything in first, because as I make alterations or additions, any change in the balance of the composition will then be immediately apparent. After all, Newton's law can be applied here. "For every action there is a reaction."

In chatting with my late good friend and noted illustrator Joe de Mers one day, I was explaining how we were taught that painting was simply a craft to be learned by on-the-job training, and well remember his following comment. After moments of deep thought he said, "painting is like a complicated chess game, one brush stroke can alter the entire balance, making it necessary to move or adjust other factors."

As you progress you will gradually build your own method, your own step-by-step procedure that will better enable you to accomplish things in *your own* way. This will become part and parcel of your "signature," that assemblage of personal characteristics and idiosyncrasies that is the very nucleus of every artist's individual style.

4 Nurturing Your Most Important Asset

The essence of painting from nature, whether it be landscape, still life, portraiture, or figure composition is that you are viewing something in three-dimensional space, and transferring it to a two-dimensional format. It is within this third dimension, actually experiencing the feeling of space as you work, that the magic of the artist's ability to create the illusion of space lies. If you take a photograph of a subject, then take it to the studio and copy it, this potential, of the eye making choices as the living world evolves under changing light, is lost. You are then simply transferring a two-dimensional image on to a two-dimensional format and in so doing are missing the whole point of your quest. This will result in the dilution and eventual destruction of your most important asset, the uniqueness of the way you observe real things and interpret them. That recognizable element, *your* intrinsic nature that is different from all others. This one ingredient, the nucleus of your personality in paint, should not be put at risk.

The camera also lacks the ability to see color in shadows and bright light. It is unable to replace the eye's ability to *see, evaluate,* and *express* color in such conditions. The camera also bears no comparison with the artist's capacity for selection and emphasis within the process of observation.

This brings to mind an occasion on which I brought in to class a small black-and-white snapshot when at Derby College of Art. I had borrowed my father's Brownie Box camera which took sixteen pictures on a 127 roll of film. I was using it to fashion a sky on a painting I was working on when our teacher Alfred Bladen came up behind me chuckling to himself. Knowing that the other four in our class were all ears, he said, "If you copy photographs, your work will take on the nature of the photograph. If instead you go outside and paint a sky from life, and while doing it think about the space between as well as the clouds themselves, and feel the movement in them, those qualities can well become apparent in your painting." Soon afterwards I followed this advice and found that, indeed, the process of on-site observation holds all the suggested advantages.

It is from my own personal experience in painting harbor scenes in retrospect that I am obliged to refer to etchings, daguerrotypes, and antique photographs for the purpose of research. Even in this necessary reference in searching for long-gone buildings or ship characteristics I sense an inducement to relegate my creative process and feel the urge to render rather than express. In succumbing to any temptation to use such references literally, one simply has to be acutely aware of the mortal danger to one's own identity that this portends, and learn to very carefully avoid its pitfalls. Another temptation to avoid is that of creating a market for paintings that are similar to each other because the subject matter sells well. Referred to as pot boiling, this habit can only display to the discerning collector that your range is narrow and that you are churning pictures out simply to gain

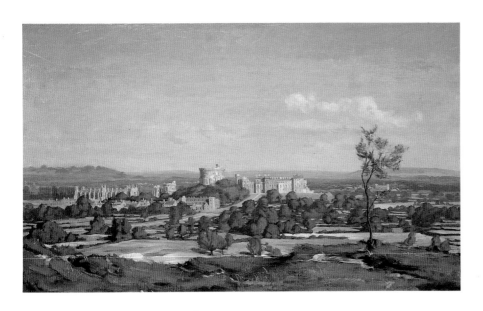

Windsor Castle from the Great Park.

financial reward, without any real desire to search for a quality that is unique and special in everything you do.

Again, artists who are influenced to copy someone else's style because that artist is successful are simply displaying the absence of their own originality and a lack of maturity. In the learning process it can be beneficial to copy or refer to the styles of the old masters, but you need to be careful not to allow any given style you like to dominate your own unique characteristics. I recall referring to a print of Corot's painting, *View of Avignon from Villeneuve* (13⅜" × 28¼), the original of which hangs in London's National Gallery, while developing a painting of Windsor Castle from the Great Park. I was searching for clues as to how Corot gets his magic quality of light and felt the exercise worthwhile as a test and would in fact never want to part with the original.

When John Constable, at age 23, entered the Royal Academy Schools in 1799 he copied, as a continuing exercise, the works of several prominent artists of the day; Wilson's landscapes, Caracci, Ruysdale, and Claude's *Hagar*. But by 1802 however, he had realized that to "seek the truth at second hand" from the paintings of others instead of from nature "meant death to your art."

But one can see that a great many artists have been influenced by Andrew Wyeth and it would seem that many such works are completed by reference to the books illustrating his paintings. The losers here are the copyists who are merely confirming to their audience that they lack the gumption to develop their own individuality or lack confidence in their ability to do so.

For the artist who has avoided the enticements of copying others' work and has followed the pure process of painting from life in his or her own way there should be no detrimental factors preventing the revelation of their own personal characteristics in their work, the very pathway to their recognition.

5 Creating a Demand for Your Work

For the majority of young artists this task is the highest hurdle. There is a fear of venturing into the unknown, of even confronting the issue, of deciding on a price and of being taken advantage of or worse, ridiculed.

Perhaps the encounter of my own first sale will help cast some light on this. The scenario might offer some tips as to how the process works.

While a student at the R. A. Schools in 1951, after beginning to realize that I was not about to make a living selling nudes, I had ventured off, both into the countryside and down to the busy Thames river producing small paintings from nature. They were done mostly on 10″ × 14″ primed boards that fitted into my paint box lid and were the best I could do at the time. A little painting of the canal at Ware, Hertfordshire was the first I attempted and by some incredible chance of fate it remains in my possession and will not be parted with for *any* price.

I had been looking around the commercial galleries in Bond Street and the St. James's area, hardly minutes walking distance from the Schools, in an attempt to educate myself as to exactly what was going on in the real art world. After all, ''Creating a demand for your work'' was not in the curriculum at the R. A. Schools, so it seemed to me that I'd better start addressing this matter early and accept the responsibility of charting my own destiny. Who else would do it?

The Canal at Ware, Hertfordshire.

The galleries in central London sell a wide variety of paintings, each with its own specialty, and at times, quite by accident, I would come across the work of an artist that would stop me cold, enabling me to have an inspirational feed. Such an experience, regrettably, can only happen to those with the good fortune to have easy access to a large city. But while investigating the gallery scene, I had taken a special fancy to a small gallery right next to the back of the Academy in Cork Street, bearing the name J. A. Tooth & Son. It displayed equestrian paintings by such noted painters as Herring and Moreland whos work, depicting the genre of the early barnyard scene, particularly attracted me. I was, however, painfully aware that entering such a pristine establishment in my painting gear would make the owner cringe so I made my visits short. But the other thing that attracted me was the incredibly seductive odor in the place. J. A. Tooth chain-smoked cigars, but the gallery was also heavily scented with the smell of mastic varnish and the combination of the two was irresistible.

''You're a student at the R. A. Schools,'' Mr. Tooth said, with just a touch of disdain as I sneaked into his gallery to get a closer look at a Moreland original. It

was part question and part statement of fact, as I was somewhat paint-stained and thereby had revealed my identity. Dealing in equestrian pictures, Tooth was "connected" to royalty and the last thing he'd want around if a customer came in was, in his eyes I suspected, the "lowest form of animal life"—an art student!

Somewhile after that I was better dressed and on my way home with several small outdoor paintings in a bag when, on the way to the tube station, I popped into the gallery again on my never ending search for inspiration.

"Ah, you're back!" Tooth exclaimed. It was late in the day and he must have done some good business. Now he smiled and engaged in talk. He was really a

St. Paul's and Waterloo Bridge from Charing Cross (a similar, if more defined sketch, to the one that attracted Mr. Marsh).

likeable fellow and as we talked I decided to show him the little oil sketches, most on board, I had with me. The result of our exchange was that he asked me to leave two of them, and although I had no idea why, I acquiesced, taking a last satisfying whiff of varnish and cigar scent as I left.

Several days later while painting from the model at the Schools a voice suddenly came from behind the screen, "Mr. Stobart please." It was the porter's voice so I downed my brushes and left the studio. "There's a phone call for you." His voice was hushed as it was not permissible for us to take calls. I instantly recognized Tooth's voice. He wanted me to go to the gallery immediately to meet someone.

The gallery was literally one hundred yards from the Schools and as I entered I noticed Tooth talking with an elegant gentleman in a homburg hat and was soon introduced to the Canadian lawyer, John Meadows Marsh, Q.C.

"What do you want for this?" Mr. Marsh asked after the pleasantries, pointing to my little sketch of tugboats on the Thames. Shocked and dismayed, as I had absolutely no idea where Tooth could have got the impression I wanted to sell the works, I replied instantly, "Oh, it's not for sale." I explained that I had it in mind to enter the sketches for the academy premium competitions. A quizzical look came over Mr. Tooth who, standing aside, looked disturbed.

After some brief moments of thought Mr. Marsh then played his ace. "What *would* you have wanted for it if you *had* wanted to sell it?" He now looked right at me with a smile.

At this point my brain raced. I was stupefied. In a second I had rationalized that the sketch had taken me thirty minutes to paint and that I was living on five pounds a week (fifteen dollars then) full board. It would take me thirty minutes to paint something else. I aimed high, hoping to resolve the problem and keep the sketch. Stuttering a reply, now in nearly mortal embarrassment I replied "Er—well—between five and ten pounds." Hardly had I finished than Mr. Marsh had taken out his wallet, counted out seven pounds ten shillings in crisp new bills, and pointing them toward me asked, "Will you take this for it?"

The sight of the fresh money was the killer. I accepted the situation, parted with the sketch and pocketed the funds together with the business card of Mr. Marsh who eventually became a great collector of my work at vastly higher prices!

The wonderful thing about paintings is that as you develop your finesse and bring them to an accepted standard they are, in fact, all "saleable" and of value to

someone. That value, sentimental or monetary, might be minimal, but it is a value. Your job is to *create* value if your objective is to survive and prosper from an income derived from painting alone.

In today's world the comparable price of the little painting Mr. Marsh bought would, I suppose, be around $200.00 to a 21-year-old student in similar circumstances. Is $200.00 for thirty minutes' work too much? too little? after five years study.

After I sold the painting to Mr. Marsh I realized I was "in business." I walked on firmer ground, felt more confident about my future, realized I could create a "following," and knew it would be possible to earn an income of sorts through painting alone.

The confrontation had taught me several lessons. That I could create something someone *wanted.* That I was not prepared for the encounter and must see to it that I would be next time. That Mr. Tooth was helping me and that there would likely be a price to pay for that continued help. That Mr. Tooth was the necessary go-between, he put seller and buyer together. That I was naive but that afterwards I wasn't. Who had the most power in the encounter? Unwittingly it was the person holding the item that was wanted. The embarrassed, confused, naive student. I could have said no.

The factors that create a demand for your work are its quality and your developed style. That it displays an element of maturity when compared with other examples of your work. That there is a consistency, one work with another, and your work is recognizably from the same person. That the artist also displays a sense of being secure, a sense of being responsible, a sense of humility that the buyer would think enough of the work to pay the price for it.

But in the final analysis, for the artist starting out it is the work itself which will catch the attention because it beckons the viewer saying, "Come over here and look at this!" So you need to be sure you have a quality in your work that *attracts* the viewer's eye. The work itself will then create the demand. All artists need to do is to see that such work gets exposure in a place where the ambience is to their preference. *This* is the point at which they may be obliged to consider representation.

Representation: Its Positives and Negatives

Although Mr. Tooth sold quite a few of my small paintings of London's river and the countryside around, he specialized in equestrian subjects, that was his bailiwick. He was somewhat like a Dutch uncle to me, enjoying giving advice and seeing it taken. Following the Marsh episode, he leaned over to me and in deadly serious tones said, "Always, but *always*, paint on canvas, never board. The customer wants oil on canvas." I took his advice.

During my final years in London I searched endlessly seeking representation. My work sold well when displayed and it was annoying to constantly hear the same comment from gallery owners, "We don't take on living artists." It was during this period that I visited my father in Rhodesia, the voyage around Africa taking some eight weeks. Making painting and sketches of the colorful foreign ports resulted in a new and very profitable venture, that of painting new ships in

glamorous ports for shipping company boardrooms. Becoming disenchanted with the art scene and the entrenched class prejudice in London, I emigrated to Canada in 1957. Finally tiring of the modern shipping scene in 1965, I spent a year in Toronto where I did nothing but study my secret love, the age of sail.

My next brush with seeking representation was a very different story. I had produced four paintings, all 24" × 36", with the indefatigable assistance of the late Alan Howard, curator of Toronto's maritime museum, and following his advice, brought them down to New York on an overnight train to "seek representation." Amazing though it still seems to me, luck struck twice that day and altered the course of my life.

Waking up in the train seat as a crowd of commuters boarded the train below Tarrytown, I moved to allow a gentleman to sit beside me who I soon noticed was looking through, of all things, books on art. Having not even a remote idea of where I was going, I plucked up courage to ask this person beside me the following question. "Where would I go to show 'averagely good' paintings of clipper ships as sea?" Thinking carefully for a while, he finally passed me a piece of paper with four gallery names, saying that they were all roughly in the same area. My paintings sat above us on the overhead rack, in a brown paper parcel tied up with string, English style. Leaving the train at Grand Central, I paused to look at the man's card. It read, Donald Holden, Editorial Director, Watson-Guptill Publications and *American Artist* magazine.

In each of the four galleries I was courteously received and to my absolute astonishment, every single one offered me an exhibition! The principal one, founded by the Wunderlich family in 1874, clearly stood out as perfect as it had class and displayed paintings by artists I was familiar with. This association with the Wunderlichs rocketed me into acceptance and resulted in my moving to the United States in 1966. The four paintings, left at three of the galleries, all sold within two weeks at prices substantially higher than I was getting in the shipping company field.

The previous story sets out my own experience, which was graced by unusual circumstances and incredible luck. This is simply not going to happen to the average student who will probably have a total of four years of college, if that, in which to get a plan together to ensure a modicum of viability upon walking into the big world with a graduation certificate.

The important thing to realize is that from *day one* at college, the student's mind set should be, "What am I going to do with all this at the end of my studies? I need to be aware that the earlier I have my sights set, the better I will be able to focus on acquiring the right assemblage of knowledge and knowhow." Colleges don't give any guarantees.

In seeking representation the young artist should be aware of the desires of the three people in the chain of events. The artist, the agent/dealer/gallery owner, and the customer, usually referred to as the collector. As I wear each of these hats from time to time, let me try to diagnose precisely what these desires add up to. If the student or young artist seeking representation is fully aware of this, it will probably save a good deal of time and aggravation.

WHAT THE ARTIST DESIRES

The wish of aspiring artists is that their work be desired. We want to be wanted. Our hope in gaining representation is that the dealer has faith in us and will help find customers to buy our work. We want to become known, in order that our confidence in the future can be assured. We want the dealer to be honest and pay us when paintings are sold without delay. We hope that out of the proportion of the funds the gallery owner makes our names will be advertised at appropriate times. We also hope that the gallery staff speak well of us to all their customers and do all they can to assure our continued success.

WHAT THE DEALER DESIRES

Dealers operate galleries that must be funded by the commission they make out of the sale of paintings, today, probably 50 percent. Dealers are *always* looking for the perfect prospect: the artist whose work they are convinced will be desired by *their* clientele. They want a long-term prospect, not an artist who will switch to another gallery after an investment in promotion has been made. They want their artists to be reliable and faithful partners in their mutually beneficial venture. They don't want their artists selling privately to their clientele—that would be disastrous. Above all they want an artist to be predictably consistent in style, production, and conduct, someone they feel proud to promote, whose work will grow in stature and value because of their efforts. They also want an artist to be untemperamental and if they want smaller paintings, or larger, for the artist to *cooperate*.

WHAT THE COLLECTOR DESIRES

Collectors are searching constantly for the one painting with enormous appeal for them. When they happen across the painting they want, they'll hope to have the privilege of meeting the artist at a gallery function. This will mean a lot to them and will cement a bond of trust and appreciation. The collector sometimes buys for investment alone, although most investing collectors buy paintings they like to live with. Collectors also might wish to purchase for social benefits, to impress their guests with a painting by a well-known artist. Most collectors have an innate fascination for masterful works of art and derive immense pleasure from owning them. The collector will be absolutely elated if the value of the work they own goes up as the artist they have invested in becomes better known.

Being aware of some of these aspirations and being able to put yourself in the position of each should better equip you for that first approach to the gallery of your choice. *All* galleries are worth investigating as you will hope to see your own work among others that are at least moderately to your liking. Talking with the gallery owners will also help you evaluate their ideas. When you do delve into that territory, be sure that your work is presented in a nice fashion and that you look organized. After all, your work itself will be the final test of your potential.

One negative in acquiring representation is that it comes at a price. No artists enjoy the prospect of paying 50 percent commission on the selling price of their works, and few understand the legitimacy of the percentage. Most galleries in New York, for instance, cannot survive unless they are selling paintings priced at

$10,000.00 and up. Fortunately there are plenty of fine galleries in suburbia that one can choose from where the costs of doing business are substantially lower. But commissions are a fact of life.

Another negative is that I have occasionally seen artists sign contracts with dealers locking themselves into a lifelong association, which leaves little or no chance for escape. I have never signed a contract with a gallery in my life, nor, as a gallery owner, have I even considered contractual agreements with artists I represent. Young artists should therefore be wary, avoiding signing any contract before a grace period has allowed enough time for them to determine whether they are making the right step. Even then, there should be some sort of clause involved by which they can amicably terminate the relationship should they ever desire to do so without damage to either party.

Sometimes, as in my own case, a relationship with a gallery is so mutually beneficial that there is no reason for a contract. Instead, the process works on mutual trust. In my own mind the whole matter of a contract implies a suggestion of conflict.

In the vast majority of cases, however, acquiring the right representation and developing an amicable association with a gallery and its staff can be one of the most rewarding things about an artist's life. It often leads to prosperity for each and the development of associations and friendships that can last a lifetime, making the whole world of painting wonderfully worthwhile.

6 The Professional Artist

U sually this term would be applied to artists who paint for a living and have reached a certain measure of financial viability that makes it unnecessary to supplement their income by additional means. Although they would never have wanted to hear it in earlier years, they have become self-employed business people and with this status comes several perquisites. You have the privilege of making your own choices and can therefore either accept or decline commissions to paint what someone else wants you to paint. In commissioned work artists are obliged to give up a certain amount of their own visualization in order to satisfy the dictates of the person paying for the completed work.

For the majority of young professionals this is an almost unavoidable step along the pathway to financial security. Again, with your destiny in your own hands, you also have the privilege of being able to set your own schedules, avoiding those time-consuming aggravations your commuting neighbors are put through every day.

But all this doesn't come without a price. The really successful professionals need far more in their bags of tricks than an ability to paint. Those who are easygoing natural communicators will be lucky. Having the innate ability to write a good letter: short, concise, and to the point, will hold great advantages and being personable in your attitude to others is a winning trait. Later in your career you'll find you need at least *some* savvy in lettering, layout, printing, and advertising as you'll very likely encounter the necessity of promoting yourself at some point. Many of these peripheral activities can be delegated to others, but this then adds to your expenses.

I have tended to shy away from delegating because, being somewhat of a perfectionist, I like my promotional material to be consistent and reflect my own personal style. This, of course, leads to a longer day and added obligations, and worse still, deadlines!

The professional artist who elects to "go it alone" is, in effect, a microcosm of a large corporation. Down the margin of the letterhead of corporations are a number of listed titles: chairman, president, chief executive officer, general manager. Then vice presidents under planning, public relations, advertising, sales. Then office management and the important secretaries, shipping divisions, and caretaking. As a successful artist *you* are all these in one person! and perhaps unknowingly, will need to exactly perform their vital functions.

In reaching a confidence in your ability to impress yourself and others with your works you will begin to realize that your talent has delivered you a certain amount of power. The power to survive, to go it alone, to reap rewards. You have created *your* world and you are sole owner of your ability.

You have struggled relentlessly consolidating your expertise. You know no one else can do what you do in the way you do it. This is exhilarating as you suddenly appreciate the reality of what you've built. When you first realize this, a smile comes over your face as you can't quite believe you've "got it."

By the time you have reached such a stage you will already have formed a good idea as to what you like doing best. What gives you the biggest kick, the subject matter of your choice. Just the same as physicians, artists will reach greater heights if they become known for a certain area of subject matter or a certain style of painting that is theirs alone. The choices are endless, but only *you* can know what you are happiest about. Then again, there is the artist's dilemma: to paint to earn, or to paint your heart's desire and chance the consequences! A good example of the latter, of course, is the genius of Van Gogh, but how many of us have a brother who will supply us with means and encouragement all our lives?

A certain responsibility of the successful artist is to set a predictable course in order not to alienate collectors of your work who have put their faith in you by purchasing or investing in your originals. This involves at least a modicum of commitment not to widely diversify your subject matter. All that remains is for you to develop the lifestyle of your choice and enjoy every moment of it.

Presentation

I don't think it is possible to place too much emphasis on the importance of presentation, and I have often commented that completing a work is a breeze compared to framing it. Acquiring just the right frame with just the right finish for a work is all near impossible. The majority of framers making the special custom-made product never see the original that they are framing. In many cases they are so anxious to please and are so proud of their own efforts that the frame, rather than directing attention to the original oil by being subordinate to it, can dominate and vie for prominence with the painting, attracting the viewer's attention to the frame itself. A few artists I am acquainted with have elected to take on this important function themselves with great success.

It is also vitally important to see that oil paintings are protected at the back. Works on canvas are more vulnerable to being dented at the back than they are by similar damage at the front. The ideal method of protection is to attach brown paper faced foam-core to the stretcher by using short brass screws with raised washers. An important thing to remember, however, is to cut breathing holes in the foam-core to assure that the front and back surfaces of the canvas receive equal ventilation (see illustration page 17, number 8).

Copyright

All completed works should bear the copyright notice, which entails a ©, the year, and the artist's name. The artist's signature on the lower face of the painting will suffice. As an added precaution, my policy is to have labels made up which adhere to the back of the foam-core backing indicating: (1) that the work left my studio in perfect condition, (2) that I own all copyrights unless transferred in part or in whole to whomever by privately negotiated agreement, (3) that the foam-core backing should not be removed under any circumstances without notifying the artist through the gallery from which the painting was purchased, and (4) that the artist does not accept responsibility for damage.

It is also advisable that all works be registered with the copyright office of the

Library of Congress on their forms. This merely involves taking a photograph of the work and submitting it with the forms and their requested fee prior to the work going on public exhibition or being offered for sale. If this procedure is followed, lawyer's costs and statutory damages in any successful litigation are paid by the defendant, if not, all costs of defending one's copyright are the obligation of the artist.

The Pleasure of Viewing Masterworks

One of the greatest pleasures of all is the untold enjoyment we get from suddenly seeing a brilliantly executed painting, either from the past or by an artist we know personally and appreciate.

John Constable's *Weymouth Bay*, oil on canvas, 20¾" × 29½". Courtesy National Gallery, London. My RAF service was spent ½ mile from this location.

Viewpoint of Constable's *Weymouth Bay* today.

Whenever I am able to go to New York or London, or cities where there are important museum collections, I feel like a mouse looking for cheese. I am off searching for surprises in window displays or even auction rooms. One simply never knows when a great masterpiece will suddenly hit you between the eyes.

Any artist who has the opportunity to visit London would be missing a bonanza of inspiration by neglecting to visit the Constable Collection at the Victoria and Albert Museum. To see how the artist tinted his canvases or millboards with a reddish

Ogling a Seago through a security grill in London St. James's district.

brown and allowed that color to be left alone in between brushstrokes, and the pure vivacity of his handling of paint.

I was personally rather shocked to see such works we now consider to be great masterpieces displayed in thin box frames. But reading a specially prepared notice explaining this gave the answer. Apparently his wishes, handed down through his family, told us that most of his oil sketches were painted on the spot and out of doors. They exercised both his powers of close observation of nature and his painting techniques, and have the character of a pictorial diary to which he referred throughout his life. Because they were intended for Constable's own personal study and not public exhibition the sketches are displayed in simple box frames.

They were, in effect, preparation for the finished canvases he exhibited every year at either the Royal Academy or the British Institution.

During my London days I'll never forget noticing the queue of prospective buyers who lined up outside Colnaghi's gallery in Bond Street prior to the opening of exhibitions of Edward Seago's new paintings. As I arrived at the Schools, literally a stone's throw away, I could see that many buyers had been there all night, each having numbered their catalog upon entry and had their choices allocated accordingly. Seago's paintings were then, and still are, proof that outdoor observation can produce remarkable results.

The Harbor Entrance, Honfleur by Edward Seago, 20″ × 24″, oil on canvas. Courtesy of R. G. Simpson.

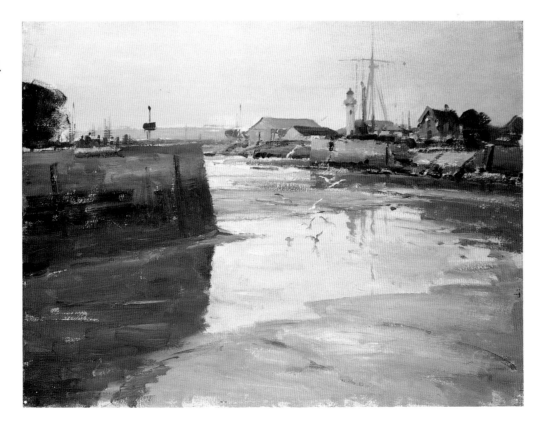

Today there is a widely growing interest in painting directly from nature, all the way from east to west. This is unusual as many of the new artists have elected to teach themselves, having been unable to find the appropriate teaching of their choice. The lengthening list of names of artists with growing reputations includes Karas, Lynch, Schmid, Aspevig, Daily, Jacob, and Chmiel, to mention but a few. A realization is returning that this is not only a cathartic experience for the studio painter, but it may well produce even greater works of art than have ever been done before.

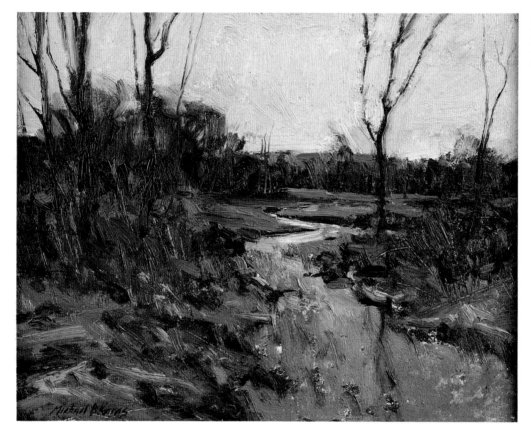

Spring Creek by Michael Karas, oil on panel, 9″ × 11″. Courtesy of the artist (author's collection).

Changing Fashions and Durability

Fine paintings that display a mature level of accomplishment and virtuosity will transcend even the most diehard attempts to replace their appeal by changes in fashion. By and large, ordinary people seem strangely strong in shunning the dictates of the art world's coterie to embrace the unreal. In demonstrating their loyalty to quality and credibility many have responded by tuning out their interest in art altogether. It is incumbent on us, and now our challenge, to try to bring their interest back to life.

I'll never forget a trip I made to the River Tay in Scotland with two artists more advanced in age than I. The year would have been 1956. I remember setting up and painting a famous salmon run beside an old stone bridge. Heather-covered

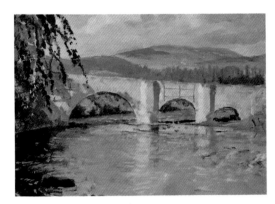

Incomplete sketch of the
River Tay.

mountains were the backdrop but the fly fisherman I'd hoped would present a focal point never came and the small sketch to this day remains incomplete.

That evening we all wandered into a small gallery in the local stone-built town to find a one-man exhibition of mostly vertical paintings featuring elongated cows. Some works showed them looking left and others right, with the pattern of the animals, mottled brown and white coats the dominant theme of each. Exchanging glances, we were frankly a bit surprised to find this happening in rural Scotland at that time. A youngish American couple had also entered the gallery and hearing our comments to each other eventually came over and introduced themselves to us. Seeming a little confused, the gentleman then asked us. "Where could we go to find a nice little painting of this area to take home to enjoy and remind us of a wonderfully memorable visit?" Deeply moved, we could only apologise and confess our ignorance of the area.

Still indelible in my mind, that short encounter empowered my resolve and convinced me that my ambition to succeed was right on track.

I personally see the artist's mission as an opportunity to offer visual pleasure rather than a chance to make a political statement or subject the viewer to shock treatment. The latter makes wonderful fodder for the media but I want to attract the viewer by carefully orchestrated illusion rather than delusion.

Being an artist is an enormous privilege, and paintings you produce may possibly last forever if properly taken care of. The legacy the artist leaves behind could well give lasting pleasure and the dedicated painter holds an even greater possibility, a chance at immortality.

Part Two

A DIARY OF THE THIRTEEN PAINTINGS IN "WORLDSCAPE"

7 St. Barthélemy
French Antilles

The painting of St. Barths was perhaps the most enjoyable and personally rewarding one of this series. I had been to St Barthélemy twice before. I visited some fourteen years ago, before its unspoiled charm had attracted the greater commercial development and volume of visitors that are apparent today, and later on a day trip from St. Maartens.

St. Barths is an island of only eight square miles and is located in the Lesser Antilles, about twelve miles east of St. Maartens. Volcanic in origin, it was discovered by Columbus in 1493 and named after his brother Bartholomeo. Inhabited later than most of the islands due to its lack of fresh water, it was eventually settled by the French. It is now a dependency of Guadeloupe.

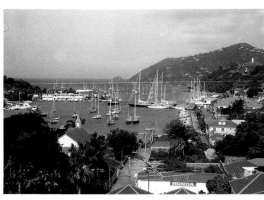

St. Barthélemy's principality and port of Gustavia.

Having always been drawn to ships and the sea and especially to harbors, I was excited about seeing the idyllic sheltered port of St. Barths's main principality, Gustavia. I was convinced that we were going to find an ideal subject among the color-washed buildings along its waterfront. We had rented a Mini Moke, a small open-sided vehicle that gave us superb visibility, but a driving and walking reconnaissance of the harbor, now more congested than on my previous visits, simply didn't reveal the magic I was looking for.

One thing I believe is certain when considering what to paint. Subjects are not *found*, they are "accidentally come across." A subject is far more likely to hit you unexpectedly when you're not even thinking about such things than is probable on a determined search.

I was reminded of an occasion when I traveled to Venice, Italy, with an artist friend who had been instrumental in persuading me to get back to painting from nature, a habit I had allowed to lapse over several years. Though Venice is crammed with subjects, I spent three whole days in endless searching before I came across a view that jolted me into action. In the meantime I had to endure the demoralizing experience of seeing my pal piling up completed works in his hotel room!

Another thing about the harbor at Gustavia was that it would have been far too complex a subject for a person starting out. Far more so than in its earlier days when inter-island schooners were the only vessels there, riding at anchor or unloading at the coral wharf. So on we drove to rediscover the appealing parts of St. Barths,

Rio della Torreselle, Venice, oil sketch of view that jolted me into action.

45

before calling in at one of the beachside restaurants for lunch. It was then, while strolling up and down that gorgeous palm-fringed beach, that I got lucky. The distant view was right, the palms were right, the beach was right, and the restaurant wall and steps were right. This would be it!

This, again, was more complicated than I'd have liked, but it had a magic about it that was irresistible and our director loved the interplay we would enjoy with people passing up and down the beach. Another aspect that I found fascinating was that we were only two hundred yards from the end of the island's only runway. Airplanes were leaping into the sky all day. This, and many of the beach activities, would add to the interest of the general viewer of the video and would be used as "cut aways," themes to switch to in between sessions concentrating on the painting's progress, revealing the island's incredible charm.

The Painting

To get the exact view I wanted I had to set up just within the part of the beach that was being smoothed out by each swell from the small breakers.

Sitting on my small stool, a folding metal camp seat, I was pleased with the way the warm sea washed over my feet as each breaker pushed the tide mark further up the beach. But each time that happened, my seat sank farther into the sand! This was soon remedied however as within my sight was a washed-up plank. Installing this under my seat prevented further sinkage.

Artists need to be practical people and not be phased by little inconveniences. Somehow, for the determined soul, there's always something at hand to help overcome most adverse contingencies.

I established the parameters (left to right) of this painting by first fixing the position of the trunk of the righthand palm tree.

Using a medium-size flat hog hair brush to continue the process of blocking in, I then needed to establish the horizon line's position in order to get a good balance between the three main horizonal areas: the sky, the distant land mass, and St. Jean's Bay that stretched from the far middle distance to the foreground.

It was initially my intention to keep the top of the righthand palm tree *within* the 12" × 16" canvas format. However, as I worked to establish the distant hills I realized that this would diminish the space I needed to focus attention on the core of the composition, the beach activity in the middle distance where the colorful sails of beached boats were catching the sun. The main palm tree, therefore, would break through the top right format limit and the painting would be the better for it.

Another compositional plus was not only the line of the lefthand hill pointing directly to the painting's focus, but also a line of four homes behind the promontory with red roofs. These also point directly to the main interest in the picture.

Such compositional factors hold the seeds of success in a painting and are there to be used, even emphasized, to drive the viewer's eye to the right spot and not have them confused, wondering what you are trying to say in your work.

The sky was left blank in this subject as I waited all day, it seemed, for clouds to appear to give me some options. Having toned the canvas with a wash of burnt sienna (a practice I borrowed from John Constable, whose method of tinting his

canvas or panel, allowing twinkly bits of this ground color to show through to help unify his results) I was ready to paint in a sky from life in one fell swoop. As so often happens, however, the clouds didn't cooperate, though did give me the idea of the large blue hole with the distant hill penetrating its lower rim.

Of course a question will arise as to just how busy you want the sky to be. It is a matter of degree as to whether a complex pattern of cloud formations might be just too much and distract the viewer's eye from hitting the right spot. As you will see from the final result, I placed my clouds in such a manner that most edges *point* to the painting's focal point.

TEXTURE

As I worked toward the foreground in this most rewarding exercise, the question of the differing textures of the beach came into question. The part of the beach that was being continuously smoothed out by the swells from the breakers reflected a pattern of color from the distant hills and sky. The rough part of the beach where people walked back and forth reflected little light and appeared darker in tone with shaded areas on each little mound. This is finicky work but such textures, if handled with concentration, can give a painting the magic element. Wouldn't it be nice to overhear a person viewing your painting say "That sand looks real!" To hear such a comment, it is well worth taking the trouble to observe such things and give them your every effort. The dedicated painter wouldn't miss that option.

Another aspect of this view was the vital importance of creating recession in the greens. From the distant peak to the foreground palm there were wide changes in values and hues. Creating the illusion of space requires utilizing aerial perspective, the way tonal and color values lessen in contrast and density as they move

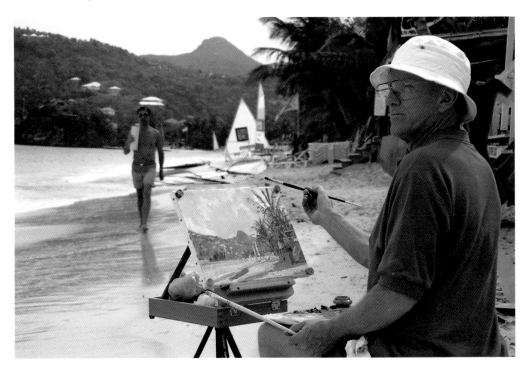

Painting at Baie St. Jean.

47

farther into the distance. It was very important to concentrate on making sure the plantation of palm trees in the middle distance, behind the colorful sails, read properly in the overall scene and were at their correct relative density when compared with the foreground and distant foothills and peak.

In finalizing my thoughts as I painted this absolutely gorgeous scene, I distinctly recall being impressed by the amount of light that was reflecting off the beach into the underside of all surfaces above it. Especially the palm trees' foliage, their tree trunks and the retaining wall of the restaurant.

Again, emphasizing the reflected light on such surfaces will make the painting seem larger than life. (Note that the lower tree trunk has direct light on the right side and reflected light on the left side.) Always recognize and use the enormous potential of reflected light. It belongs in your bag of tricks. Don't fail to use it!

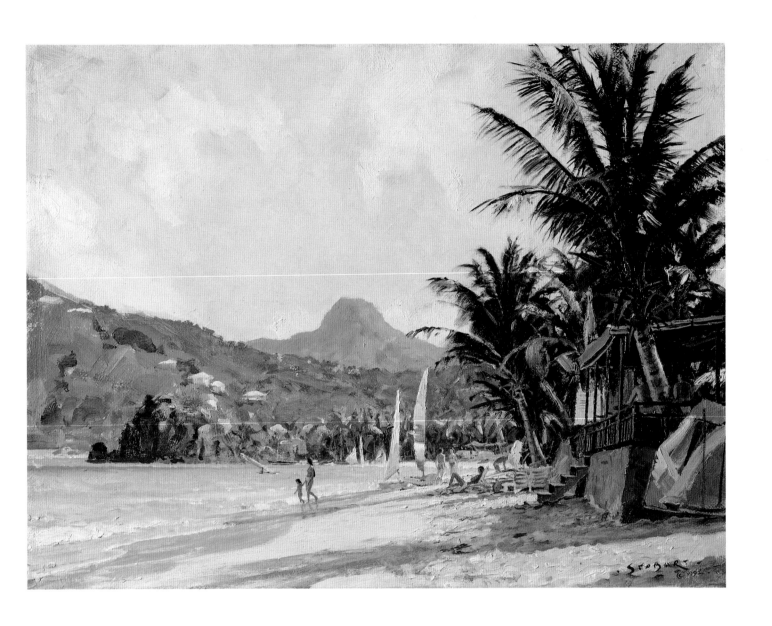

ST. BARTHS

A view of the beach at Baie St. Jean.

8 Beer, Devon
South Coast of England

A delightful small town on the south coast of England, Beer is located in Devon, land of the famous cream teas. It was our privilege to have this subject chosen by our special guest artist Trevor Chamberlain, today England's most popular and revered on-site painter.

I saw my first Chamberlain painting twenty years ago in the home of a fellow artist in England, grouped with several other paintings, including one of my own. What struck me immediately was the distinct characteristics inherent in Trevor's style. The picture, fairly low in tone, showed a vessel out on the mud in one of England's many tidal estuaries. It was well organized, well painted, and had some little flicks of light that caught the eye and beckoned the viewer for a closer look. Something about the work really appealed to me and I hoped that it would not be long before I'd have the pleasure of meeting the artist in person. This was to come about several years later when Trevor, who "didn't fly," was eventually persuaded to get on a plane and visit the U.S.A.

Another distinctive factor about Trevor's work is that it can serve as a model for other painters. It is simple, yet subtle, small yet spacious.

In working along with me he had decided to use his Pochard box, a small paint box that contains all necessary gear but can be held in the left hand (or right hand if you paint with your left hand) like a palette with a box attached. It is absolutely ideal when working in difficult conditions and is perfect for working from the comfort of a car seat, under protection from blustery or inclement weather. Usually Trevor works with a Pochade box that takes 7" × 10" panels that he prepares himself.

After Trevor stayed with me several years back, he presented me with a small painting he had completed with his Pochard box, done in twenty minutes while he stood on a corner of Seventh Avenue, New York in the drizzle. I was considerably impressed. It is a superb work and an absolute treasure to have in my collection.

A Pochade box.

Trevor had suggested we both paint from a small elevated area on Beer's seafront where people can view the fishing boats being winched up the steep pebble beach (large pebbles that is). We both painted the view looking east with the huge chalk cliffs catching the late morning.

The day was gorgeous with hazy sunlight and a heavyish sky. Perhaps it was the brightness of the sun's dazzling light on the face of the chalk cliff but the blue of the sky seemed dark to the eye.

BEER, DEVON

Sketch completed by Trevor Chamberlain while standing in the drizzle on 7th Avenue, New York City (author's collection).

The Paintings

I will begin by letting Trevor Chamberlain describe in his own words the main points of his progress. He titled his work *The Beach at Beer, Devon*. It is a 7″ × 10″ oil on panel.

"Several things attracted me to this subject, not least the strong diagonal composition of the warm chalk cliffs cutting against the cool sea and sky. The gray pebble beach too was an important feature, contributing its own subtle hues to the overall color harmony of the subject. The few accents of stronger color here and there, especially the suggestion of people and deck chairs shimmering in the warm summer sun, appealed to me.

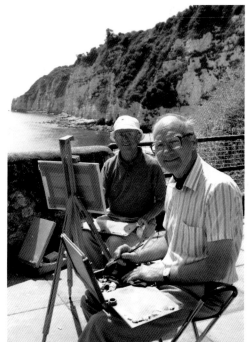

Ready, steady, go! With Trevor Chamberlain, about to make a start at Beer.

Trevor making progress using his Pochade box.

51

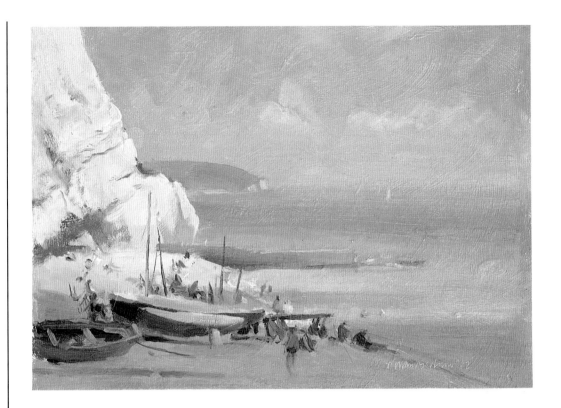

THE BEACH AT BEER

by Trevor Chamberlain.

"As the picture was painted using a Pochade box (which is a device having its origins in the nineteenth century), the size of the image is quite small, 7″ × 10″, so it was essential to simplify and select from the general clutter and bustle on the beach. The cloud shadows serve to accentuate the intensity of the main sunlit area, and also to soften the diagonal design, as do the masts and the jetty."

What especially impressed me, besides enjoying watching Trevor's painting come to life, was that he was so cooperative. He has a reputation for being a loner when it comes to painting. He doesn't like onlookers. He highly amused us by telling us how he ignores passersby even when they talk to him! He considers this to be inconsiderate trespassing in his private world of concentration. To prevent people from approaching him he'll often hold a brush in his teeth, which tells the curious passerby, "How can I talk if I've got something in my mouth?"

But Trevor buried all these traits, giving us a wonderful show in the process.

His method of working is to block in after some very brief drawing with a brush. He works quickly with intense concentration, drawing with the paint and simplifying shapes. He loves atmospheric effects and uses any means to achieve his ends. He will sometimes drag a cloth down over the paint to subtly diffuse detail toward the edge of his format in order to concentrate interest in the focal

points. His trees are almost smudges, often worked in with his finger to soften edges, then he adds touches of leaves as a mere suggestion of detail.

His figures, again, are mere suggestions, no feet, and hardly any modeling, yet the figures seem to be real and moving. In so doing he leaves his viewers some work to do on their own.

An analogy could be drawn to a novel. Whay are there no pictures in a novel? The answer is that it would upset and infringe on the reader's ability to imagine the world they are reading about. Invading the readers' world almost mocks their ability to allow the imagination to run free. Likewise the viewer at all times should be offered the opportunity to share in the painting's illusion, even though this may not be a conscious effort.

What fascinated me about Beer was its similarity in many respects to Cadgwith Cove, Cornwall, where thirty years earlier I had watched fishing boats being winched up a steep cobbled slope to the safe area above the high tide mark. As the boat climbs the hill, men will slide greased wooden logs in front of them in order that their boats' keels and undersides are not worn rough by the large pebbles.

Small craft of all types and sizes were strewn about the beach between piles of lobster pots and other paraphernalia. The smell of seaweed, the cries of gulls, and the dazzling white of the chalk cliff only enhanced the scene in which men were going about their everyday tasks, of preparing for the next fishing trip or lugging ashore the fruits of their endeavors at sea.

My painting of this subject was a joy to complete. I began by establishing what segment of the canvas I would devote to the cliff. Then I decided to move two fishing boats over from their position closer to my right. I was especially keen to include them as being an essential part of the Beer scene.

The most important next step was to establish at the outset the color key of the painting by deciding on the relationship between the sky and the cliff. This was new ground. I was determined to somehow emphasize the dazzling surface of the chalk in full sunlight. Without further ado I found myself carried away by the cliff's surface, feeling a need to make the most out of this extraordinary opportunity.

Tufts of grass spotted the cliff but it was the light hitting its crevices that created its sparkle. This was almost like painting white eggs on a white plate in full sunlight! The reflected light from each of the myriad of surfaces was bouncing into everything nearby.

The two fishing boats I moved into my composition from the right.

To give the illusion of the brilliance of the cliff I found (by trial and error) that the only solution was to substantially lower the tone of the sky, even below its apparent color. Only in this way could the sharp contrast be accomplished.

The beach itself is made up of small rounded rocks from 2" to 5" in diameter and was noticeably lower in tone than the cliff. Its "local color" was blue-gray but in the brilliance of the direct sun it was warmer.

Then came attention to items on the beach. Small pleasure boats, wide rubber beltways for easy walking access to the boats

53

over the pebbles, ramps with rubber-tired wheels to assist in boarding boats themselves. All of these items were new to me, and of a totally different character from items on a comparable beach in America. Before our eyes the strong winches pulled newly arrived boats up the steep beach like toys.

This was a good and enjoyable day. Perfect weather, good sandwiches, and good people! Some noisy sandblasting had threatened to upset our filming, but upon being approached, the sandblasters actually delayed their efforts for three hours to allow us to continue. Their consideration, the subject before us, the smell of the sea and the warmth of the sun made me wish every aspiring outdoor painter could have been looking over my shoulder that day, experiencing the joy and pleasures life as an artist can offer.

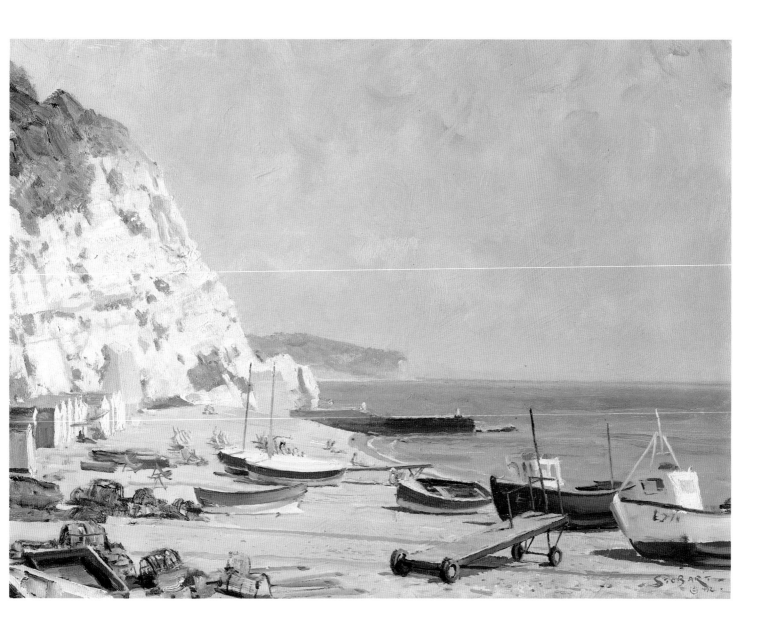

BEER

A view of the chalk cliffs, looking east.

⑨ Greenwich
Connecticut, U.S.A.

The one factor, above all others, that inspired this series was the collector's enthusiasm for my retrospective harbor scenes which, in effect, recreate our lost ports before all evidence of them is washed away by the rapid progress of a changing world. Finding when I came to the United States in 1965 that the mid-nineteenth-century harbor scene had not been recorded by artists of those days, with very few exceptions, I accepted it as a worthy cause and began some twenty years of rediscovery.

Ever since I was a student at London's Royal Academy Schools (1950–1957) I had leaned toward the exciting subject of ships in harbors, a subject which had, through the generosity of the Keeper at the Royal Academy, ensured my viability as a young professional artist by the time I graduated from the R.A. Schools in 1957. This evolved into a period of some ten years completing commissions for shipping company boardrooms, depicting their proud new vessels in ports all over the world.

Although as a student I had produced a large number of small on-site landscape paintings, principally done in the countryside outside London, it was apparent to me at that early stage that my fascination for ships and the sea was far likelier to propel me to establish my own individual niche than were the more bucolic and restful rural works.

After emigrating to Canada in 1957 I was finally able to follow a desire to study the relatively recent history of sailing when, in the mid-nineteenth century,

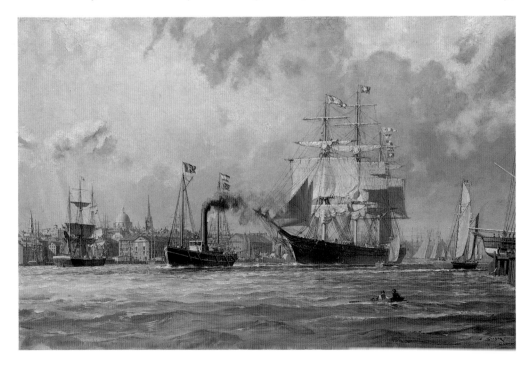

The McKay clipper *Lightning* leaving Boston on her maiden voyage in 1854.

56

progress in American naval architecture was the envy of maritime nations through-out the world. The renowned clipper ships were slipping down the ways of Donald McKay's yard in Boston. America had become preeminent in sail.

In the art world, however, few painters expressed any interest in recording the era of merchant sail, apart from one or two noted artists in Boston. The fact that the rest of the country went unrecorded fired up my enthusiasm to devote my efforts to rediscover the glamorous harbor scenes of the 1850s to 1880s for the next twenty-five years, and recreate the atmosphere of the day.

A special attraction for me when I resided on the Connecticut shoreline in the early 1970s was in discovering that at the turn of the century it was a major produce-growing area for the markets of New York. I had painted the little port at Rings End Landing, Darien, where I lived and ever since then had hoped I would find another similar subject. I particularly enjoyed the combination of the maritime scene with the riverside landscape.

In choosing to paint retrospectively, the artist becomes somewhat vulnerable, in many cases unwittingly, to a working process that obligates the use of reference material. Since the chosen scene no longer

Rings End Landing, Darien, Connecticut.

exists, a whole host of questions arise involving in-depth study. In the retrospective harbor scene this would involve learning about things we seldom, if ever, see anymore. The construction and working of carts of different types that hauled the produce the ships carried; the anatomy of the horse, the sailing ship and all its complexity of rigging, and the processes behind handling its working parts, the wharfside architecture, and period dress.

Having heard about the landing at Cos Cob, the little port serving Greenwich, Connecticut, I ventured down to the Greenwich Historical Society to find out exactly where the landing was located and to see whether it would make an appropriate addition to my on-going series of retrospective paintings. Not minutes after walking in there I realized I had hit the jackpot!

Not only did their headquarters figure as a meeting place for some of America's major artists of the turn of the century, but the landing at Cos Cob was practically outside their front door at the head of the Mianus River.

To me, the shocking thing about this discovery was that the whole scene of the former wharf-side area is now buried under the concrete overpass of I-95, the New England Turnpike!

The view of Greenwich today from exactly the same spot!

The Painting

Looking through files of old etchings, and prints from glass plate negatives of the period, I came away armed to the teeth for the battle ahead. In no time I had made my way to what was left of the wharf, now in the permanent shade of the huge overpass. Horrified as I was, the very sight of this immediately fired my enthusiasm to dig this lost port out of its dingy graveyard and bring it back to life. This would then allow it to be appreciated by those who could otherwise have absolutely no idea that it ever existed at all.

Then came the essential next step, which has made outdoor painting such an important part of my life as an artist. So that I can invigorate my studio work with the true character of the location, which could take five weeks or more to complete, I like to fashion an outdoor, on the spot, oil sketch of my idea of what I want the final work to show. A sort of shorthand note to myself, not taken too far, but with all the pertinent ingredients that I feel will epitomize the nature of the place.

The on-site sketch also serves to establish the proportions of the final work. Sometimes I will want a standard two measures high by three measures wide format, but occasionally a larger area of sky is called for so the format needs to be higher. In the case of the Greenwich original my instinct was to go wider, and I finally ended up with a 21" × 34" canvas.

My inspiration for this subject was high during the entire period I worked on it. I really *felt* for that port. The early glass plates I had seen revealed it to be the sort of place I would have loved to visit and walk around. The strange shaped roofline of the gristmill to the left of center, set my imagination buzzing. What was it like inside? What were the people like?

Initial on-the-spot sketch of Greenwich subject.

My enthusiasm gathered momentum as I started work on the canvas, knowing that I was going to use a shaft of light from the early morning sun (at my right), and *create* light by casting low shadows over the lefthand waterfront, enhancing the sunlit surfaces.

Having completed this type of scene many times before, my instinct always tells me at the outset that I will be able to breeze through it. Just what it is, however, that prevents this from happening, I don't know. But it seems that there are always new challenges in a painting of this type that require dedication to the craft to pull it off.

Regrouping the cluster of buildings to the left, by reference to the glass plates of the wharf taken from other angles, was quickly accomplished, but balancing their scale within the composition took far greater effort than I expected.

Having passed the point of no return, about halfway through the painting, I realized that the horizon line I'd so carefully established, had to come down about ⅜" to perfectly achieve an ideal balance. When such realizations occur, I am quite ruthless about making any change necessary, whatever the cost in time. But I was saved again by the important option of restretching the canvas, by the procedure of taking the trouble to round the corners of the stretcher, preventing the canvas

from cracking along the edge when I stretch, and the most important factor, leaving the tacks proud. This time I didn't have to laboriously scrape down and repaint. Instead, I quickly took the canvas off the stretcher and restretched it ⅜" lower. This averted arduous reworking and in less than half an hour I had restored the top edge and was making progress.

Using Color to Your Best Advantage

In painting the Greenwich subject I wanted a special effect of light, to a certain extent dramatic, yet retaining the tranquility I felt would be a factor in the early morning light. As well as the essential of accurate drawing, this work called for special attention to the use of color.

When painting skies I always recall a comment from my first teacher in Derby, Alfred Bladen. He was an eccentric character but was so dedicated to our class of five (two being ex-servicemen from the Second World War) that our respect for him was total. He came up behind me once when I was putting in a sky behind a figure composition that was part of our curriculum.

I was putting it in all in one tone when he came up behind me and offered, "Don't forget to show changes of color, as your sky moves from top to bottom, and side to side. You are painting it like a door."

It was the "like a door" that became etched in my mind, just as many other words of wisdom he offered us, and every time I paint a sky those same words pop up again.

Having come some distance since then, I will try to explain how best I now handle color in big skies.

At first a wide ¾"–1" brush is used to apply sporadic strokes in the approximate color I want to end up with. Already established in mind was the use of a certain shape of cloud at the upper left. This cloud would be toward orange on the light side and with the complement (blue) on the dark side, scattered clouds could be added later, dark or light, but my concern was to avoid that upper corner distracting the viewer's attention from the focus of the painting, the side of the gristmill (center left).

The body of the sky would be greenish blue, and more toward blue at the top of the canvas, then receding to a gray/pink in the far distance.

My system then is to crosshatch strokes of different colors. The "blue" of the sky was created by crosshatching certain soft tones of pink and green. This has the effect of making the sky more luminous. In remembering the French painter Seurat's pointillism, we can see that to get a certain color he would split a particular color into small "points" of the colors that made it up. A similar thing happens in photolithography. If a square inch of magazine illustration was enlarged to a square foot, the effect would look very similar to the Seurat style, displaying an array of dots of pure color. This creates a vibrancy that is lost when your colors are mixed on the palette, then applied as flat colors.

Likewise, again taking a cue from Seurat, when I get to the foreground, I like to get lots of color on my palette and load the brush with several tints without swirling them into a flat color on the palette, but instead let the separated colors

appear on the canvas, their mean arriving at the tone I want. This obviously takes a good deal of practice, but the principle is to reveal the makeup of each color by *unmixing* it, thereby creating a more vibrant effect. Obviously there are degrees by which this method can be utilized. A certain amount of experimentation with the method might give you an added insight into how you can add extra life to your painting. There is nothing more useful than observing the way the masters used paint. Sometimes just by close examination you can pick up terrific tips.

I get a tremendous kick out of bringing one of these bygone locations back to life, and sometimes sit and stare at the canvas as it nears completion, lost in contemplation about the extraordinary period that passed us all by.

The idea of producing limited edition prints of such major retrospective paintings was born out of the fact that after all the considerable work, the original would be lost in a private collection, perhaps never to be seen or appreciated again by anyone but its owner. With subjects so carefully researched and painstakingly executed, of scenes that are now buried in antiquity, exclusive print editions are just about the only way to ensure that a wider audience will be able to share and appreciate them.

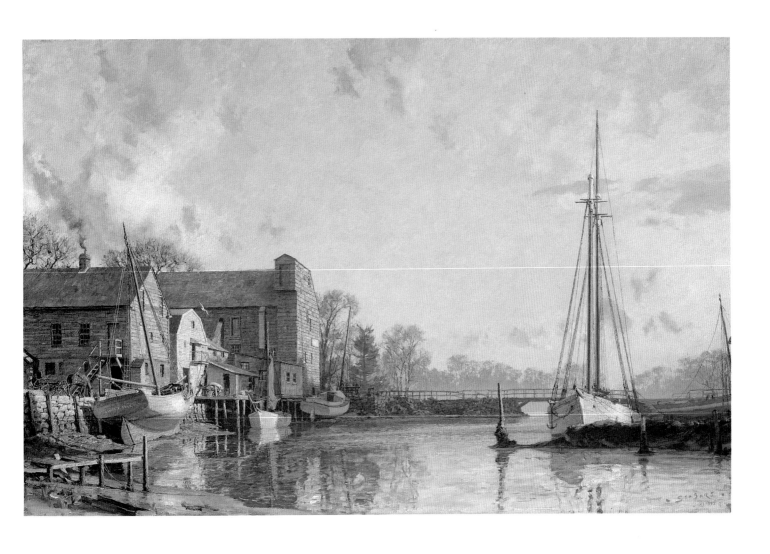

GREENWICH

A view of the lower landing, Cos Cob at sunrise in 1895.

10 Hilton Head Island
South Carolina, U.S.A.

Familiar to many by its red and white lighthouse in Harbourtown, Hilton Head Island is a barrier island off the South Carolina coast, just north of the Savannah River.

My first visit to the island in 1974 was in connection with the commission I accepted through Joe de Mers, to paint the picture of the S.S. *Savannah* shown on page 105. The illustrator had retired to the island's Sea Pines Plantation ten years earlier when its harbor area was undeveloped. But Joe's foresight convinced him that it would develop into a major recreational area for golfers, tennis players, and fishermen and he quickly decided to open his own art gallery there and move to the island permanently.

When I first had the opportunity to visit Joe de Mers's gallery I was immediately impressed. His gallery, overlooking the circular harbor at Harbourtown, reflected his taste and knowledge of art and gave me a new vision of the benefits of owning such a business in such an upscale resort community. I was so captivated that I bought a small property on the Intracoastal Waterway side of the island, knowing that I would enjoy returning to the warmer climate and socializing with the group of artists who had moved there from the New York area.

In considering Hilton Head as a subject for our series, I was especially keen to invite the celebrated portrait painter Joe Bowler to participate in the video presentation. He responded graciously and invited our team to visit his studio where we were able to see his recent portraits. For me, the intriguing aspect of Joe's work is that he does several smaller conceptual paintings of his sitters in order to give them various options from which to choose, before he progresses with the major works. Seeing all these displayed in his studio along with some very charming nude studies was a special treat for our team.

Nude study by Joe Bowler.

Study of a young girl 12" × 9" by Joe Bowler.

Visiting Joe Bowler's studio as he develops a larger work from the sketch on the left.

We were also very fortunate to be able to chat with Joe about our mutual concerns for the art student in today's world. During the past three or more decades so few art teaching institutions have been able to survive the pervasive influences to abandon the disciplines necessary to learn to draw and paint in the manner handed down to us over centuries of dedicated progress. Thinking of the student, it was a pleasure to hear Joe wax so eloquently about a subject so close to my heart.

In deciding on a subject for our Hilton Head segment, I was attracted to the shrimp boat docks at the north end of the island. Taking a look at the area I was surprised to find that a shrimp boat I had painted once before, named *High Noon*, had been retired, and was berthed on the inside of Mr. Hudson's new dock where it was unobstructed by other dock paraphernalia. This gave us a clear view of the vessel and we were assured that while I worked on the painting the dismantling of its rigging would be delayed and other vessels would not be moved in to obscure our view.

The Painting

Quickly establishing the composition of the Skull Creek painting, I was influenced by two principal factors. First, I wanted to use at least part of the overhanging oak tree, which was laced with several swaths of Spanish moss—the one element that I felt would categorize the subject as being of the deep south. Secondly, the reflections of the shrimp boat and its dock, and the edge of the foreground bank of the creek would both help to resolve the lower portion of the painting.

Skull Creek has a tide of some six or seven feet and this was to pose something of a problem. As we were starting at low tide, the shrimp boat would move up substantially over our two-hour filming period—which I anticipated, from previous experience, would extend to three or even four hours. I countered this from the outset by painting the vessel some three-and-a-half feet *above* where I observed it as I blocked in. In other paintings I have done of this area I have enjoyed showing the characteristic and extensive mudbanks that appear at low tide and the oyster beds that top them throughout this wide channel of the Intracoastal Waterway. The moving tide and its variety of options could confuse a beginner. Such changes can be discouraging, as features you have carefully drawn in can rise or fall to new positions, altering the whole scene. One aggravating aspect of outdoor painting is that, more often than we'd like, the subject looks better later on than it did when we started, then we are torn between making a major change or soldiering on with what attracted us in the beginning. Part of this is that the subject looks *different* rather than better, and if the situation had been reversed and the sun had gone backwards, we might well have preferred what we initially started out with anyway.

Having painted maritime scenes all my life I enjoyed studying the retired shrimp boat. It had obviously seen better days and I loved noticing the details that gave it character—the wear on its wooden fenders and its name, perhaps painted on by a crew member. Mr. Hudson told us that it was over fifty years old and was now in the process of giving up its workable gear to other vessels in need.

12.15 pm. 12.25 pm. 12.40 pm.

I established the sky early on in our session so that painting the shrimp boat's masts and rigging would be helped when the sky became tacky later that day. As I worked along I felt displeased with myself that here again I had chosen a more complex subject than I'd realized—too complex for a beginner to contemplate.

The light on the vessel's side changed rapidly. Too rapidly for comfort, and would under normal circumstances require my returning the following day, in which case the tidal change would need to be taken into account, as well as the right angle of the sunlight.

REFLECTED LIGHT

Another thing that caught my attention while working on this painting was the strong play of reflected light in the small area at the right of the wheelhouse where light off the shed was bouncing back into the white paint of its curved surface (1). As the sun moved slowly away from us this reflected light bouncing off the shed diminished as the intensity of light on the shed lessened. The sunlight moved off the shed's surface altogether at one P.M. But even so the deckhouse front was still receiving reflected light, now from its own foredeck!

Reflected light on boat's hull.

The student observer should notice and look out for these plays of reflected light as, if they are carefully used, they will make your painting look larger than life. Here is your opportunity to slightly emphasize an effect.

Boats in water always reveal reflected light in their shaded areas as light bounces back into them from a profusion of reflective surfaces in the water (2). Observing such effects and utilizing them will result in your work being enhanced with the illusion of light.

A quick way of demonstrating the power of reflected light would be to go outside on a sunny day with a mirror and a colored or white sheet of paper. Simply look into the mirror holding the sheet of paper away from the shaded side of your face and notice how it reflects its color into the shadow of your face. Everything seen has a measure of reflected light in it. The realization of this will give you an extra tool to give added life and vibrance to your work.

As I completed the Hilton Head subject I put in the overhanging branches and foliage

Painting at Scull Creek

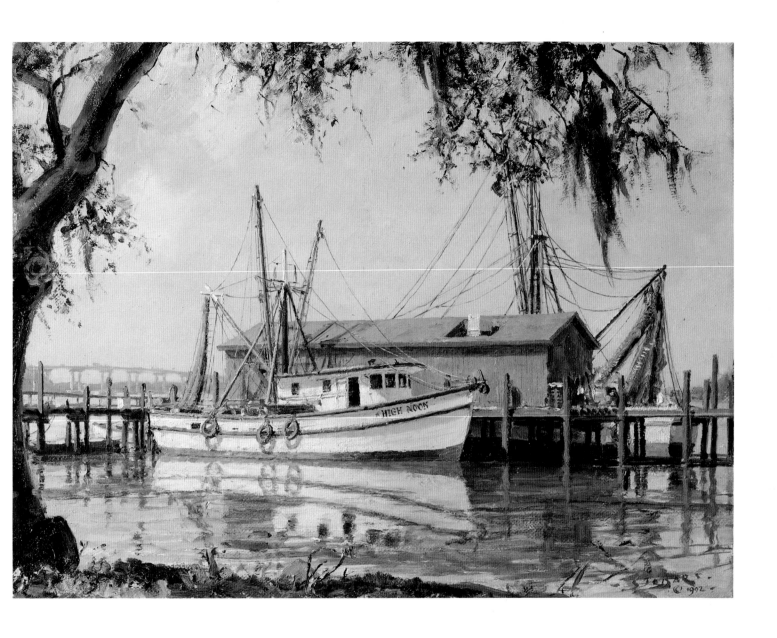

HILTON HEAD ISLAND

Shrimp boats at Scull Creek.

but was sadly dissatisfied with my attempts to portray the Spanish moss. By far the best thing would have been to return the following day but our team had to move on and my hand was forced into finishing up when the light had changed. In the end I left some of the moss in, but took some out, necessitating some repair the following day.

The serious painter will appreciate that adding such a feature late in the day can change the balance of your painting, especially if it has not been indicated as a rough feature earlier and left in position in rough form. Adding major items late can tend to spoil an otherwise pleasing result.

I think this painting perhaps reveals my love of shrimp boats. Also the shed and all the docking with its pilings and cast shadows on the vessel's hull add up to a pleasant memento of a happy day. As an artist this is your prize! A piece of immortality for you to keep with pride, sell, or give away.

11 Honfleur
France

Having never been to this French town before, it turned out to be quite a discovery. A Normandy fishing village over a thousand years old, Honfleur is located on the west side of the mouth of the Seine opposite LeHavre. Both cities serve as sentinels protecting the access to Rouen and the heart of Paris.

Surviving the ravages of successive wars, the port is an eyeful of preserved architectural gems, from the Lieutenance, called so because the king's lieutenant's residence was built above its fortification, to the town's ornate gateway, to the tall narrow buildings surrounding the inner harbor, to the unique bell tower of St. Catherine's church.

But for the newer fishing boats, the traffic, and the inhabitants' modern dress, the visitor to Honfleur today walks right into a scene virtually unchanged since the celebrated French artist Eugene Boudin painted its scudding skies and the promenade at nearby Deauville a century and a half ago.

Having read about the port in books featuring the famous French artist I was not expecting to be quite so moved by the stunning reality of its charm. As is the case of most European cities, Honfleur is compact, as it was designed so that its inhabitants could easily traverse their entire town. At its periphery, buildings end abruptly and the countryside begins.

Enjoying walking along the town's streets and experiencing the countless views across the inner harbor, I was soon cataloging hosts of possible subjects. The group of buildings known as the Lieutenance offered the greatest inspiration as

they were grouped in a clump right in the middle of the port, between the outer harbor, which is tidal (twenty feet) and the inner harbor, which can only be accessed by water at high tide when its lock is opened briefly.

There is hardly a single name in the list of prominent painters of the mid-nineteenth century who has not painted in Honfleur, whether it be St. Catherine's church with its wooden belltower or the port and its surrounding buildings. Painters who frequently visited the town include Monet, Jongkind, Courbet, Turner, Isabey, Millet, Whistler, and the Barbizon painters Corot, Harpignies, and Daubigny. Most of the artists would stay at Madame Toutain's Saint Simeon Farm outside Honfleur, today a hotel.

The lock at Honfleur.

The major reason artists are attracted to

Honfleur, of course, is that its tremendous wealth of subject matter is all within just a few minutes' walk. I found that checking each viable subject at different times of the day for lighting changes as the sun moved to the west posed little inconvenience. The characteristic the town is best remembered for is its varied and often scudding skies, which had so captivated Boudin and other Parisian painters. Being on the north coast and with the constantly moving weather patterns being affected by the Channel itself, the clouds are nearly always on the move and changing, making the variety of options to suit your composition simply endless.

The final characteristic of the port worthy of mention is that the outer (tidal) harbor has enormously high stone piers making fishing boats at their berths completely disappear from sight at low tide into the mud-bottomed caverns between. If one therefore wished to paint fishing boats at high tide showing the Lieutenance as a backdrop in a certain light, it could be a matter of waiting a week or two to hit the right sunlight and tidal combination.

Settling in on one subject out of so many possibilities was again, by necessity, governed by the mechanics of the filming process. The variety of angles from which to shoot was quickly to eliminate my first choice, which would have placed my back against a doorway. My second

Fishing boat at low tide.

choice soon evaporated because the viewpoint was right on the town's busiest intersection. I did however manage a small 9″ × 12″ oil sketch of the subject and vowed on the spot to return to Honfleur to try both these subjects at a future time.

For my own part Honfleur is an absolute must to revisit. Not only to paint the two scenes I had to miss out on, but to enjoy its ambience and the cuisine of its absolutely delightful restaurants.

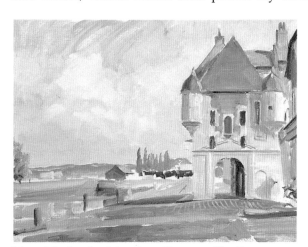

My quick sketch of the Caen Gateway, Honfleur.

The Painting

The choice of view which satisfied the film crew's requirements was the north aspect of the Lieutenance. A fairly simple stone building with an uneven surface above which, to the left, was the historic Lieutenant's residence. This group of buildings stood well back from the inner harbor's stone wall where steps led down to the water's edge.

At the time I chose to do the work on this painting, the inner harbor was enjoying some festivities which involved a parade of yachts in celebration of a

special cause. The two old sloops in my composition were apparently in urgent need of preservation funds and were on special display on that very day off the Lieutenance to elicit donations.

Having these two historic craft in just the right spot gave an important subsidiary feature to the painting. At the left I wanted to include the roof of the Lieutenant's residence and at the right I liked the idea of showing the lock gates, which at high tide were opened briefly to allow for arrivals and departures. This was a simple composition and posed no particular challenge. The principal attention therefore was to the drawing (meaning structuring) in order that everything fit within set parameters. The sky was certainly no Boudin sky on the day we filmed but what was there was perfectly pleasing.

Complimentary Colors

As I was progressing with the painting, I felt that something extra was needed to make it a little more vibrant. To give it something that would make it more than a mere copy of what was before me. After some experience in the field you will find that you will begin to assemble a variety of methods to increase emphasis. In this case I decided to upgrade the complements, but being very careful to keep this marginal.

Complementary colors are those that are opposite each other on the color wheel (see page 79). Their use can present just the right opportunity under certain circumstances. If a subject lacks spirit, or could be edging toward the ordinary, a wonderful way to enliven it could be to marginally increase the complements. If the wall of a building in sunlight is beige, an option would be to brighten it slightly by adding a touch more orange (red + yellow). To keep the balance right the shaded side of the building should then receive a compensating touch of the complement blue. The building you are observing will already have these elements, all you are doing is emphasizing them slightly. If there is a shadow cast on the ground or over any adjacent surface, make that shadow marginally darker. In other words you are increasing the color and tonal contrast slightly above what you observe. The whole will then appear brighter. All this takes some experimentation.

The magic of using complementary colors can best be realized by placing them right next to each other. A red against a green, for instance, will "vibrate" to the eye at the place where they meet. Opposing each other, they will shimmer and be uncomfortable to look at. This phenomenon can be used to advantage by the artist in several ways to emphasize the color contrast between opposing surfaces of light and shade to give the illusion of more punch.

Progressing following blocking in.

Another factor about complementary colors is that the complement can always be used to lessen the chroma. In other words, if you've made a color too bright, a touch of its complement will lessen its intensity and is the way to do so.

The execution of the painting went very well and the video best describes the process and sequence of what I accomplished that day. I enjoyed concentrating on structure and scale, working as quickly as possible so as to catch the afternoon light before things altered radically as the sun dipped toward the horizon. The lock, sky, and landscape to the right were a vital element in this view together with the two boats in the left foreground. All contributed to making this simple scene worthwhile.

Since completing the painting a surprising amount of viewers I have shown it to have preferred it to some of the others in the series. This alone reveals a curious fact. It is simply that as you progress you will find that all paintings, in the long run, will attract an admirer. A happy thought indeed!

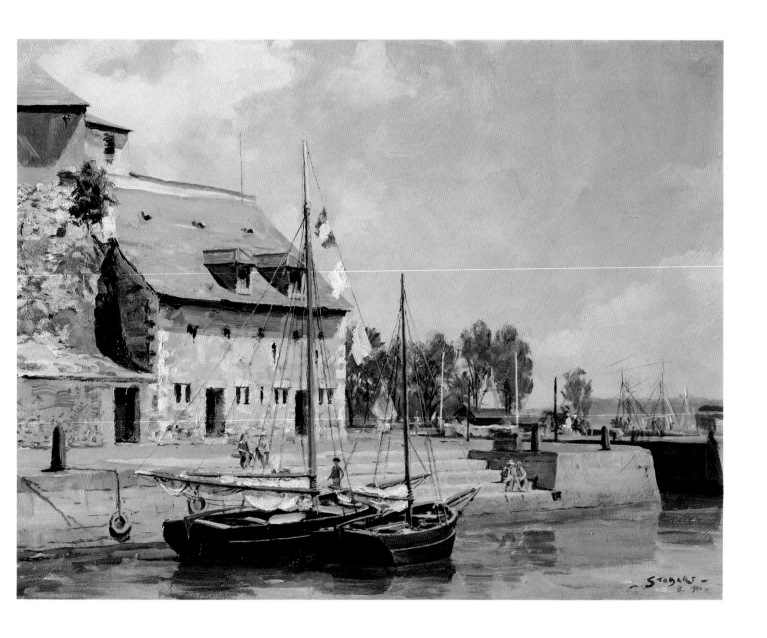

HONFLEUR

The Lieutenance from the Inner Habor.

12 Jersey
Channel Islands

My fascination with islands began at the age of eight when I was taken to the Isle of Man which is located in the Irish Sea halfway between England and Ireland. The one thing that became etched in my mind during that little adventure was that the place had "toast-rack trams," small street cars that reminded one of a toast rack.

To the visitor, islands seem to give the impression that they are a world of their own, and I distinctly recall getting such a reation on my first visit to Jersey's companion Channel Island of Guernsey. It was the first time my father had relented to the idea of my taking a girlfriend on holiday with us and we all stayed in a hotel in Leree.

"Toast-rack" tram, Isle of Man.

Strangely, my memories of Guernsey include scant recollections of the absolutely delightful young lady who was along. What did stick indelibly in my mind, however, was the variety of things that the island is famous for.

Most British folk are avid gardeners and during the Second World War just about everybody with an available square foot or more of land grew a victory garden. Ever since that time I have been an inveterate tomato grower and I already knew that one of the things the Channel Islands are famous for is their tomatoes.

Unlike my brother George, I failed miserably at school. This led to my being passed up for boarding school and I therefore ended up being virtually in charge of weeding or otherwise monitoring our family vegetable garden. We were reminded constantly that this activity was *our* contribution to defeating Adolf Hitler and Co. But at that time the era of global warming hadn't yet begun and with tomatoes needing plenty of sunshine, even my best dedicated efforts in those English Midlands were pretty pathetic. Seeing tomatoes grown in the Channel Islands, however, was another story, and for me, a revelation.

The things that endeared me to the Channel Islands were the industrious farming techniques, products such as new potatoes (small white potatoes that didn't need peeling and were absolutely delicious when boiled with fresh mint),

Jersey's friendly cows.

and early tomatoes that were harvested out of vast complexes of greenhouses. And of course the islands are home to the Guernsey and Jersey cows. Clean looking, almost deerlike in complexion, brown-eyed beauties that are revered the world over.

My good friend, watercolorist Bert Wright, had suggested to me that the island of Jersey would probably offer greater potential for subject matter because of its more varied terrain and more accessible coastal areas. We duly arrived there via the Condor high speed catamaran from Weymouth, England on June 13, 1992.

Picking out a hotel in a row of old buildings below the huge Orgueil Castle at Gorey on Jersey's southern shore, Bert had suggested that I wouldn't have to venture far from there to find a good subject. He was dead right! But first I had to eliminate from my mind a vision, an ideal example of what I really had hoped I would find in Jersey.

We rented a small minibus and proceeded to drive around the entire island in an attempt to find the characteristics I was seeking. The thing I was really hoping to find was a group of buildings, perhaps farm buildings, that would be toward the edge of the island's plateaulike form, but with a dip in the land revealing the ocean beyond. Well, I drove that vehicle for two days experiencing all the variations of changing light in the process, and searched every narrow lane, many with the undergrowth at each side pushing against each side of the vehicle, before coming up empty-handed, almost alienating our crew in the process. This shows the fallacy behind searching for your ideal.

Often remembering something my paternal grandmother had apparently ingrained into my father's mind, "What you are searching for is often to be found nearest to you," it came as no particular surprise that the three backup choices of subject were all less than half a mile from our hotel.

One was a view of the castle at Gorey from the high point of land nearest to it. Another was a similar view from farther away looking between trees over arable land. The third was a cluster of buildings with a beach beyond, a middle distant silhouette of trees behind a ploughed field sloping toward the shore to the left. Our third possibility was selected because the viewpoint had several surrounding vantage points from which the cameraman could show me at work. Another factor about this choice was that I had noticed it each time I left the hotel and remember thinking it was fairly close to the ideal subject that I had initially sought, a view that would epitomize the character of the island, a rural and argicultural paradisc.

The Painting

This time I had chosen a smaller, 9″ × 12″ format as I felt this would help in simplifying my task of encouraging the beginneer to attempt something similar.

The way in which the sun hit the white gabled end of the group of buildings was the key to this composition's success. Another aspect I liked about it was the simplicity of the shapes. The high horizon line with minimal sky was a departure from my usual preference but in this case helped focus attention on the cluster of buildings with the curve of the far beach intersecting with them at just the right spot.

As I worked along I could hardly believe the rapidity with which the entire body of water vanished from the scene as I worked. I had not been aware that I was starting the sketch on a falling tide! In no time people, hardly discernible in the distance, were walking all over what had been covered in water only minutes earlier. This was a negative, as I preferred, and kept, the body of water in the view as it had appeared when I began. I liked its shape and the way it contrasted so nicely, the blue against the dazzling warmth of the main building in sunlight. It also enhanced the effect of the dark green foliage of the trees against the bay's area of water.

Another factor that had attracted me to this view was the reflected light on the shaded section of the cluster of buildings. There was obviously a sunlit surface on the other side of the street they were on, bouncing the sunlight back onto their facades. What I had failed to realize as I began work was that in less than one hour the sun had moved at such a surprising rate that it would soon move off the very surface that was the basis for my whole composition!

Under normal circumstances the plan should then be to interrupt your progress and return the following day at a time the effect that had attracted you would reappear. Many times a day's delay will bring you back to work refreshed and more familiar with the subject. Carrying on when the light has completely changed can be a frustrating business and somewhat demoralzing when the magic that inspired you in the first place suddenly vanishes. At this point, however, I had completed the work on the buildings and was grateful that I had chosen the smaller format.

Jersey. Working on location.

The reason I still prefer this view to the other three considered, is that its composition is so agreeable. The buildings are cupped in an arc starting at the upper left and ending at the lower left, extending to the righthand edge of the format. The vertical poplar tree to the left nicely joins the foreground to the middle distance and the furrows in the foreground field also help to establish the arc's shape. For the beginner, this would not be a frantically difficult job to attempt, but remember, first check the tide *and* the position of the sun at the outset so that you can be certain that the light won't substantially change in the two-hour time span.

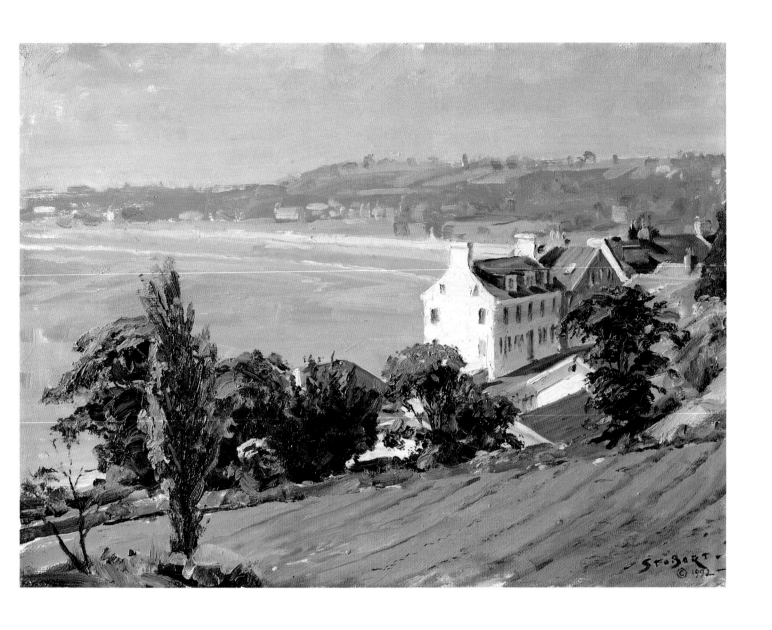

JERSEY

A view near the Channel Island town of Gorey.

As cannot be stressed too often, the underlying secret behind good painting is good drawing. It is an absolute essential to your success as a painter that you have an intuitive understanding of structure and perspective. The aspiring artist who has a strong desire to paint simply has to realize the crucial importance behind making a major investment in time and effort to acquire a solid knowledge of the basic fundamentals of good drawing. Such finesse comes with a consistency of effort but yet is easily within the reach of anyone truly motivated and is also well within the reach of the student who is not privileged to be able to attend college for the purpose.

Drawing and painting are not *taught* but are rather self-taught with a minimal amount of guidance. After all, you are learning to paint in your own way. Success is attainable to anyone with the right conviction of purpose and motivation to achieve competence in the craft through constant practice. At first it will seem difficult, but each time you go out you will notice a slight improvement as you pick up confidence. The thrill will come when you compare your twentieth effort with your first. By then you should be pretty thrilled about your progress.

13 Laguna Beach
California, U.S.A.

Ever since I first read Richard Henry Dana's classic novel *Two Years Before the Mast* I've had a fascination for the southern Californian coastline. Dana had the powerful and unique ability to make his readers feel that they were looking over his shoulder as he witnessed the scene on the West Coast in 1835.

Some years ago when I traveled there for the first time, I simply couldn't wait to go and find the edge of the cliff overlooking Dana Point. The principal trade at that location then was in hides. They were bought from the Spanish ranchers for a dollar each, then shipped to Boston where they fetched four dollars apiece. The "hide droughers," as they were called, then returned to the West Coast by sailing around Cape Horn with their holds filled with manufactured goods, utensils, shoes, and clothing and all manner of hardware that was marketed to the coast rancheros from what was virtually a floating store. When the ship was empty it would then be reloaded with hides for the return trip to Boston.

One of Dana's jobs as a crew member was to descend the cliff on a rope at day's end to release hides that had got stuck in the crevices when they had been thrown from the cliff top to the beach some four hundred feet below. They would then be rowed out to the ship anchored off shore. To me, visiting the very place where all this happened was a revelation. Right at my feet were the "prickly pears" he spoke of and, plain to see, right there were all the crevices in the cliff! But for the enormous marina now taking up the brig *Pilgrim*'s anchorage, it all could have been just yesterday.

The West Coast was barren then with scarcely a tree in sight. I've seen an old photo of Belvedere Island, San Francisco Bay with hardly a tree on it and an early painting of Santa Barbara with its famous mission standing almost alone in a clear open valley. Trees came much later.

Laguna Beach is a resort town between Newport Beach and Dana Point, growing in popularity following the expansion that followed the construction of the Santa Ana freeway and the development of Disneyland. In the past it has enjoyed a reputation as an art colony, but today is perhaps better known as a prime residential area for the wealthy of Orange County.

In considering Laguna Beach as a subject for our series I was able to ponder over several potential and equally attractive aspects for a painting. All were along Cliff Drive, where I'd been attracted to the distant coastline, ending at faraway Dana Point. Nearly all the choices were equally attractive; one I recall had a palm tree in the near left foreground with the same distant view framed under overhanging leaves—a great opportunity for nice thick foreground brushwork—but there was no adjacent space for the camera crew. In the end, it was again the availability of nearby vantage points from which to shoot the character of the coastline, yet still follow the progress on the painting that forced our decision.

We had come across a concrete slab halfway down the cliff that overlooked

superb rock formations beyond a foreground beach. The waterfront buildings of Laguna Beach were ideally positioned in the middle distance with Dana Point ten miles away in the far haze.

The Painting

We began our filming on a pristine day with a clear blue sky (1) and from the first brushstroke the painting moved along beautifully. Sometimes you get really lucky. You feel just right and the day is perfect. It is hardly possible that things can be expected to go that well every time.

I felt good about the relative simplicity of the composition with its five well defined areas. The significant features were the shape of the distant land mass (2), the area of the foreground cliff (3), topped with the gazebo of Las Bresas restaurant, and the curved edge of the beach with its variety of interesting rock masses (4).

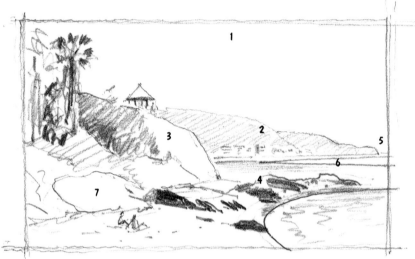

I especially liked the opportunity to have an "escape" into the distance with the promontory of Dana Point falling just inside the righthand edge of the composition (5). This also gave a perfect opportunity to emphasize the effect of recession.

I thought the blocking-in process in this segment was just about the best of all the thirteen paintings, showing the composition being established with a big brush in simple definite strokes. Here was the perfect place to reveal the vital importance of being able to *draw*. Good drawing takes constant practice, but when you have accomplished a familiarity with structuring the composition before you, whatever the subject might be, blocking in will move along easily.

My way of beginning might occasionally vary to some extent, as in the case of the St. Barths segment where I begin by establishing the position of the righthand tree, then move quickly to establish the central position of the distant mountain. But in most cases my favorite method by far is to get the whole canvas covered with paint so that by the time I am doing finish work the former paint is tacky and pulling the new paint off my brush. It really doesn't matter a whole lot if you don't get the color right at the beginning, but it is a good idea to aim close. Lightening a sky for instance after blocking it in too dark would pose difficulties. Depending on the degree of change it might be best to remove the blocked-in sky with a palette knife and/or paper towel so that you wouldn't have to paint light into dark. You can also correct your basic compositional shapes when the paint is wet by using your forefinger wrapped in a paper towel. This is especially useful if you change your mind and want a light area where you have blocked in dark paint. The former dark paint should *always* be removed first.

I generally give my first attention to the sky following blocking in, working

from the distance to the foreground. For instance, painting a sky in *after* you've painted a tree would pose great difficulty unless your competence level is high and you do it purposely to get a special effect.

Following the initial blocking in, it is your choice to select what area you prefer to work on first. The greatest difficulty about working on-site is that the sun won't stay still! Your choice of first area to work on may therefore be determined by such contingencies, with any hard-and-fast, step-by-step approach being inappropriate. Instead, you may need to work fast to get a particular lighting effect before it vanishes from your sight. Certain conditions in front of you will determine how you proceed.

A factor I particularly enjoyed in the painting of Laguna Beach was the opportunity to point out the shapes that constantly changed within the body of water. A long triangular shape (6) revealed itself for a while and as it virtually pointed to the core of the subject (the buildings on Laguna's shoreline) it was an ideal shape to use.

THE COLOR WHEEL

It was during this subject that I took time out to explain the color wheel in a rather simple manner on my palette. This merely identifies the primary and secondary colors in the spectrum, the way light splits up when refracted off a prism. The same effect evolves to produce a rainbow which is sunlight (refracted off raindrops) split into the spectrum.

The primary colors are red, yellow, and blue, which produce the secondary colors orange (red + yellow), green (yellow + blue), and indigo/violet (blue + red).

The colors directly opposite each other on the spectrum are termed complementary colors. Green is the complement of red, indigo of yellow, and orange of blue. It is very important to remember this basic information as one can use complementary colors to enhance the effects of color contrast in certain instances (see page 69).

As *all* colors emanate from the primaries, you should be able to acquire any hue by using the primary colors alone. The pigments that are available to us, however, are made up of chemicals of different origins and so using the primaries alone would not necessarily always enable you to achieve the entire range of more vivid secondary colors.

As I worked along with the Laguna Beach subject I noticed blue-gray streaks that I assumed must be clay deposits in the soft rock of the cliff (7) to my left. In fact there was a wide variety of colors all throughout the cliff area that added to the interest of that particular feature. Another thing that impressed me was the tone of the dark rocks by the water's edge. With all the light that was bouncing around off the water and the bright sandy beach, I was surprised that these rocks appeared so starkly dark. But again, they added significant interest to the whole.

This painting was done on a slightly wider format, 12″ × 18″, and in completing it we went way beyond the two-hour window of opportunity due to all the interruptions necessary for the filming process. Yet surprisingly, the changing light direction had little effect on the view before me. The one thing I did decide to alter, later in the day, was to lighten the dark mass of the backlit distant coastline, which in the afternoon became hazy.

The changed effect gave a terrific opportunity to enhance the view by emphasizing the recession to the far distant Dana Point. It was almost like getting a home run in the ninth inning!

Although the thirteen paintings completed for this series each has differing characteristics as to composition and development, the video of this Laguna Beach subject stands out in my own mind as the one that perhaps will best appeal to the student, showing the ease with which a painting can progress. Also, sitting on my fold-up camp seat in that absolutely gorgeous setting with the smell of the sea, the sight of the coastline fauna and the clarity of the air on that beautiful day gave me a wonderful feeling of the exhilarating pleasure painting outdoors can bring.

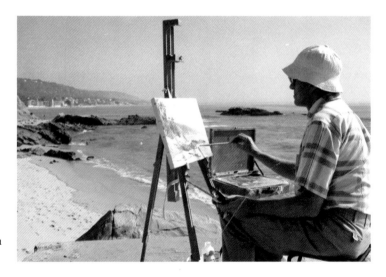

Working on-site, Laguna Beach.

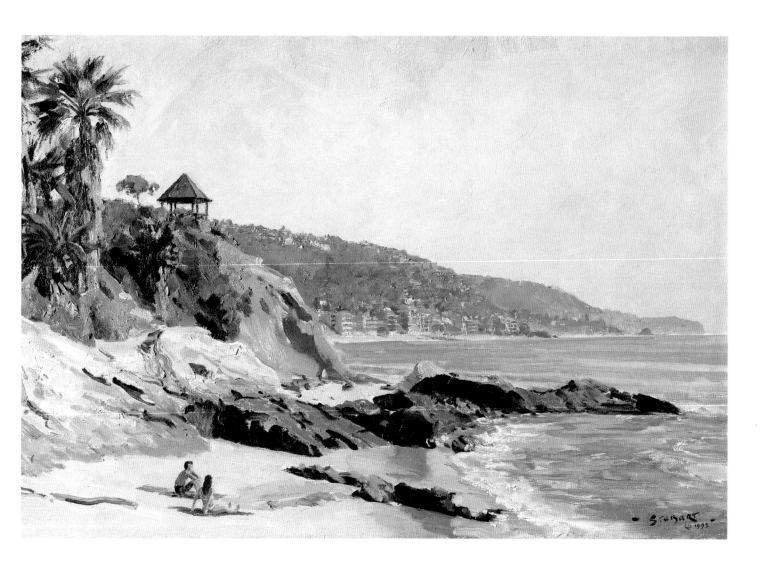

LAGUNA BEACH

The California coastline, looking south.

14 Lyme Regis, Dorset
South Coast of England

This delightful old town on England's beautiful Dorsetshire coast was selected as a subject with the kind help of my good friend and noted watercolorist Bert Wright. I was absolutely delighted that Bert had agreed to be one of our first guest artists on the video series, as it would clearly demonstrate our difference in approach as well as the change in medium.

I had met Bert Wright after he had contacted me while on a trip to America with his fellow members of Britain's Royal Society of Marine Artists in 1978. Inviting him up to a studio I then had in Potomac, Maryland, I soon discovered that by pure coincidence, we had both been at art school at the same time. He in Nottingham and I in its virtual twin city of Derby. Each being respective county towns, both cities had a College of Art, administered under the auspices of Britain's Ministry of Education. Following a period during which he produced architectural renderings of projected municipal developments, Bert spent several years as head of BBC TV's scenery group covering all outside broadcasts. This activity ended when he woke up one day and suddenly decided to do exactly what he wanted to do for the rest of his life—paint from nature in watercolor.

Every time I sit down and paint (Bert by contrast nearly always stands) I know full well that there is always that faint, if unlikely, possibility of a true masterpiece being produced. All it requires is a combination of the arousal of all the senses by the sight of a promising subject, high motivation to do well, and an appealing character of light.

Our interest quickly settled on the cobb, the snug harbor created by a semicircular breakwater with its characteristic row of stone buildings to service visiting boats. We both decided that setting up adjacent to each other would allow the film crew to better monitor our respective progress in the two mediums. We chose a spot at the edge of the inner harbor jetty that had a commanding view, not only of the harbor buildings but of the town of Lyme Regis beyond and the rolling hills of the south coast in the distance.

Town center, Lyme Regis.

In making a choice of subject I have had great difficulty navigating between choosing something simple that the aspiring artist could feel comfortable tackling, and a view that epitomizes the nature of the area we are visiting. This was obviously fitting the latter requirement, but again, somewhat at the expense of the former.

For my own part I set about simplifying the scene and felt fairly comfortable about the eventual result. The compositions we both chose differed in that I cut the row of dockside buildings in half. Bert, however, decided to use their entire length. This whole exercise was to demonstrate that each artist,

Bert Wright at work.

even when painting the same subject, will come up with a different result. A result that will reveal their own individual characteristics and ways of selecting items for emphasis.

That brings me to a point I am always reminded of when I see watercolorists working. This is simply that their medium dries out rapidly and any brushstroke applied cannot be altered or adjusted without greater difficulty. This generally requires some minimal drawing in so as to be sure that the composition is balanced before paint is applied. The purist watercolorist would refrain from using opaque white, but this presents technical difficulties that require a measure of finesse when, for instance, a white mast reaches up into the sky. The white highlight will need to be carefully avoided while the sky is being washed in. All such items need to be carefully planned, and herein lies the major difference between the oil painter and the artist who uses watercolor. The watercolor medium is hard on the artist who needs to make any alterations, whereas the oil painter has no such pressures. For this reason I raise my hat to the accomplished watercolorist; the medium requires true virtuosity.

As I watched Bert begin his painting of the Cobb that day I saw him sketch out his composition in light pencil, establishing the view we would see in his final work. I was conscious that his work would develop quicker than mine and was anxious therefore to concentrate on my own painting for the remainder of the video shoot. Why don't we now let Bert tell us his own story.

"For many years my wife and I have had the pleasure of traveling from our home in London, England to visit and paint with John at various locations throughout America. Like John, the majority of my paintings are of maritime subjects but I also paint a wide variety of subjects for various commissions and exhibitions. Living in London enables me to paint subjects ranging from street scenes and markets, river scenes, parks and palaces, in fact the tremendous range that a large city can offer.

"The majority of my works are completed out of doors in one session. Attempting to complete a painting even the following day is often unsuccessful as the lighting and general conditions are never quite the same. Watercolor can capture fleeting effects of nature. When mastered, this challenging medium can be immensely rewarding.

"During each year John and his friend Anne usually visit us in London, visits we all enjoy. This year we all traveled to Venice and then on to Florence where John and I went out painting most days, both cities being a painter's paradise. Upon our return to London John had kindly invited me to participate as a guest in his new video series extolling the virtues of outdoor painting. We duly drove through some of England's most beautiful countryside to Lyme Regis, one of England's most ancient harbors."

The Paintings

BERT WRIGHT'S PAINTING

Bert Wright describes his painting: "I have always tried to use a palette of limited colors. All artists have to develop a range of colors that caters to their

individual taste in order to better create their own personal signature or recognizable characteristics.

"In my own case this range includes raw sienna, burnt sienna, French ultramarine, cobalt blue, Winsor red, and cadmium yellow pale. The watercolor paper I used for this painting was French handmade Arches 300 lb. rough. The brushes I used are a mixture of sable and manmade hair.

"I started the painting by sketching in with light pencil the broad outline of the salient points of the composition I had chosen. Due to the fact that there can be no alteration, such a guideline is an essential in order to plan and proceed with the watercolor's progress. Alternatively, I make this rough compositional sketch with a brush using a pale wash of raw sienna that easily blends into the finished painting.

Bert's painting, in progress.

"The next step was to begin finish work by painting the sky, usually the starting point in a watercolor landscape. I used an underpaint of raw sienna with a touch of burnt sienna as a pale wash and then coblat blue for the sky areas around the clouds, carefully allowing areas of blue to merge with the still wet raw sienna where I needed it.

"With the primary part of the painting, the sky, established, I then proceeded methodically to complete the distant cliffs, gradually working toward the middle distant town of Lyme Regis to the greater contrast of the foreground detail to complete the painting.

"Watercolor has become generally known as a 'one shot' medium. That is, you only have one chance of getting it right. This is because overpainting in watercolor or attempting to correct an error tends to decrease the luminosity of the painting; the colors begin to look muddy. This of course assumes that you are using transparent watercolors only.

"If body colors such as gouache or acrylic are used the 'one shot' criteria of course does not apply. Personally I find that the luminosity of pure watercolor, which allows the paper to shine through the color wash, cannot be achieved by any other method and I do not use either gouache or acrylic. I therefore always go for the 'one shot.'

"In pure watercolor you must therefore have an exact idea of what you want to achieve before you put brush to paper as you will be unable to correct once the painting is under way.

"Naturally, it requires extensive practice to develop a familiarity with the technique. When working on a sky you may need some sharply defined edges on the sunlight side of a cloud; this will necessitate that the paper be dry, whereas on the shaded side the colors will need to blend into the blue meaning that you will be painting 'wet into wet.'

"It is a difficult medium, but with perseverance can produce effects of light and

shade and color in a way which I believe no other medium can achieve. I have had forty years' experience in painting both in a studio and outdoors and I find outdoor painting from nature to be essential in capturing the elements that not only make a painting vibrant but also make painting an enjoyable experience. My suggestion is, try it, you won't be disappointed!''

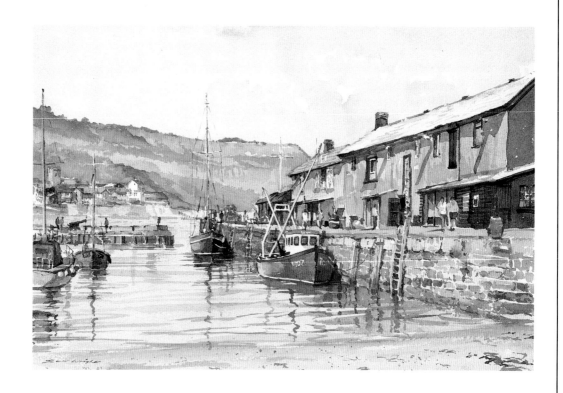

THE COBB AT LYME REGIS
by Bert Wright.

My painting came together in a different way. At the outset I was attracted by two sets of stone steps, one in the right foreground and one in the left middle distance on the far pier. This seemed to me to *enclose* the composition nicely in a quite natural manner, almost as if they'd been placed there for my benefit!

Another factor I liked was the formation of the distant town of Lyme Regis to the left background across the bay. When we first took a look at the subject the evening prior to the filming the red fishing boat was sitting on the harbor's sandy bottom leaning against the wharf. This, too, I felt I wanted to keep.

As I began, starting with the sky, the sun was still behind the main wharf buildings, but knowing the sun would move around to the front of the structures I knew I'd have a chance for a cast shadow from the roof onto the building, the first essential in creating the illusion of light. This, too, I would keep.

Compositional sketch

Frankly I was not crazy about the red boat's design. It was new and the cabin was off center. Halfway through our filming a much prettier blue fishing boat arrived, which I was contemplating exchanging for the red one, but just as I was coming to a definite conclusion the blue boat left. Eventually, I put the red boat's cabin *on* center and lived with it.

Working on a picture like this has to be done methodically, one area at a time. Describing every brushstroke of the progress would be exhaustive and uninspiring to the reader. What I like to do instead is raise each factor that affected my thinking about the whole painting, or significant parts as I worked along.

Those righthand foreground steps, for instance. They sloped inwards, the thought being that anyone who slipped on them would fall *away* from the water. After having painted them in precisely as they were, I thought, "Viewers who see these are going to think I've made a drawing mistake!" I duly changed them. I think Bert, on the other hand, left them as they were. Such a silly thing to have to contend with.

The big moment of the day came at about 1 P.M. when someone mentioned getting a sandwich. It was then that I made the best decision of the day. I suggested we share England's greatest, and as far as I'm concerned, unchallenged gourmet delicacy, fish and chips. It was so absolutely delicious that I simply could not find words to describe it. Maybe it is better now since they stopped the habit of wrapping the whole mess in newspaper and pouring vinegar all over it.

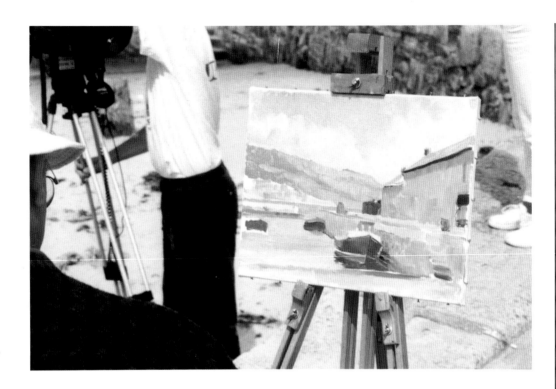

John's painting, shortly after blocking in.

When I think of when I first went out painting I recall getting discouraged. The essential thing to remember is that you need to clean off your palette three or four times at least during work on a painting of this size. This will help prevent your colors from getting muddy. The whole idea is to keep the colors fresh. At all times you should have a paper towel in your left hand and when this gets even marginally clogged, change it for a new one.

Always try to establish your composition early so that you're not making major adjustments halfway through the job.

Begin with the sky (the farthest away part of your scene) and work downward and toward you. Bert has told us about the watercolor technique. Watching him work, it looks easy, and fast. Obviously I prefer the oil medium because it poses no limitations. Work can proceed at a leisurely pace and alterations are relatively easy. I was always taught to use thin paint for the sky and thicker paint toward the foreground, but I've seen some superb work that does not use this rule.

The whole point of it is that each artist should develop his or her own way of accomplishing the end result. This will come through seeing styles you like and through your own experimentation. Above all you should absolutely *never* copy from pictures or photos. *Always* work from life. Progress might be slow but it will be real, and in the end, you'll reach the payoff, you'll impress *yourself*.

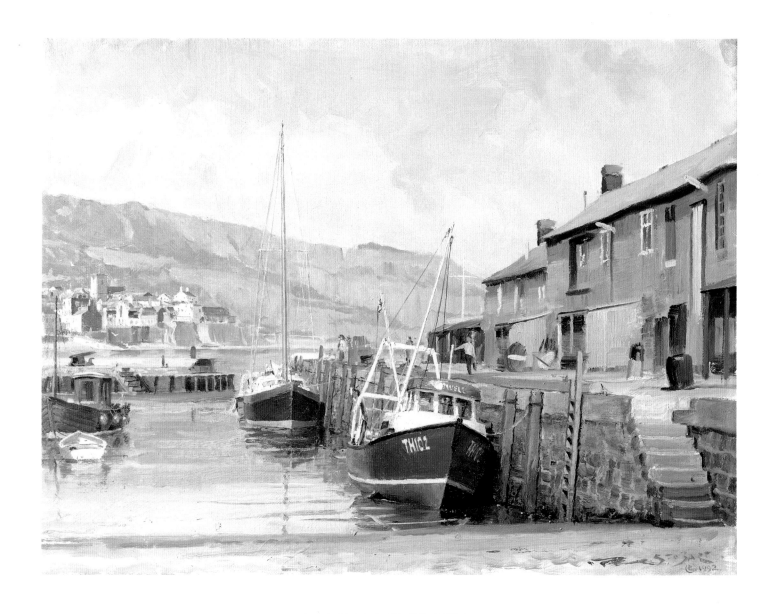

LYME REGIS

A view from the Cobb looking east.

15 Martha's Vineyard
Massachusetts, U.S.A.

This location was where we first got our feet wet and proved that filming and making comments while concentrating on painting was a practical possibility. I had checked the location of Hart Haven the day before and instantly fell for this ideally suited scene.

Martha's Vineyard is an island off Cape Cod in Massachusetts, west of Nantucket, but closer to the mainland. About twenty miles long, it is seven miles wide and a favored summer resort area for New England's wealthy as well as many famous celebrities.

Having visited and painted in Nantucket many times, I decided to locate my summer studio in Martha's Vineyard because of its more convenient forty-five-minute ride, by car ferry, to the mainland. The island abounds in good subject matter for the artist, other attractions are its excellent surfcasting and offshore fishing, and for me, beautiful vistas over the ocean and a perfect climate for growing fine tomatoes and other summer crops.

I also find the style of architecture on the Cape very appealing with its cedar shingle facing and white trim, the scene enhanced by picket fences and an abundant variety of deciduous and evergreen trees.

With my studio close by, we chanced a mid-October (1991) day for this initial segment, secure in the thought that if the weather turned bad we could run for cover to my nearby home. To our surprise, however, we were absolutely thrilled to find the temperature had climbed to eighty-one degrees as we arrived at the site, a good omen, we thought, for the series, and there wasn't a breath of air coming over the inlet's surface as I set up my gear on that beautiful beach.

The Painting

I felt from the very beginning that this composition was classic. Had it not been for our show, I would have wanted to produce a larger painting of this view. As we began, the scene before us that morning was stunning.

The trees on the right were in a nice group with light filtering through them to the ground cover foliage that was beginning to turn color. It was most likely our dreaded local poison ivy!

The lefthand side revealed conveniently lower trees (one should always avoid having similar-sized silhouettes on both sides) and the boat at the dock was in exactly the right spot, about a third of the way from the righthand edge. Of course I'd have just loved to have included a local catboat at the dock as there *was* one at the pier in the middle distance. But our director, an avid art student himself, advised that I should not deviate from the pure process of painting exactly what was in front of me. The subject boat before us was, in any event, of a classic period design and looked terrific tied up to the pier.

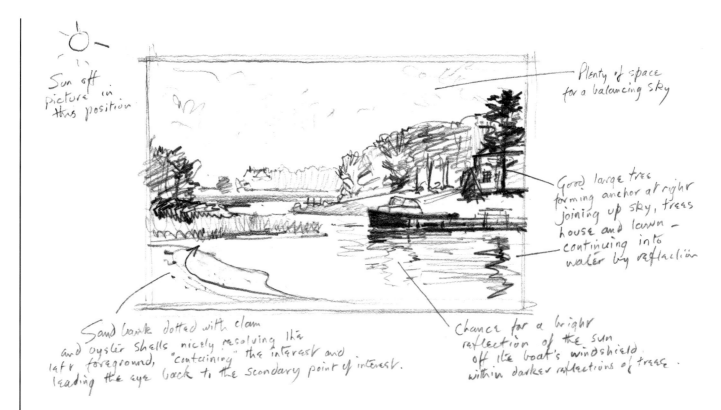

Sun off in picture in this position

Plenty of space for a balancing sky

Good large tree forming anchor at right joining up sky, trees house and lawn — continuing into water by reflection

Sand bank dotted with clam and oyster shells nicely resolving the left foreground, "containing" the interest and leading the eye back to the secondary point of interest.

Chance for a bright reflection of the sun off the boat's windshield within darker reflections of trees.

Rounding off the compositional elements was the house in the distance, to the left of a stand of trees, and the waterway threading its way through the center of the scene. Then, right in the foreground, as if ordered in for the purpose, was a nicely textured beach, perfectly resolving the lower left corner. How lucky could we get?

Commencing the painting on this spectacular day was a big treat. It was one of those days when I knew from the first brushstroke that I was home free. As in most cases during the series, however, my qualifying thought as I progressed was that it was a trifle busier than the average student would want to tackle, but by this time I was already carried away.

Nearly every brush I own is a *bright*. Strangely, though having painted for forty years, I never knew the term used for them until the necessity came up of having to explain about them for this series. I simply picked up brushes in stores that I thought looked good and took them to the counter!

To see if the parameters of what you want to show will fit into your format, it is usual to quickly sketch in the salient points. This should be done with thin paint that can be easily absorbed in the blocking-in process. Sometimes you might find you need a slightly higher canvas proportion, or slightly wider. This initial brush-in will quickly reveal any necessity to change format proportion. To be prepared for such any such contingency, I always like to have 9″ × 12″, 12″ × 16″, and 12″ × 18″ canvases with me on outdoor trips.

Using a big brush I again got the canvas covered as soon as possible. A mistake most beginners make is that they always seem to want to fiddle about with a little brush, and begin concentrating on detail, trying to *finish* something — anything!

MARTHA'S VINEYARD

This reminds me of reading about a very famous person who, upon taking up painting as an avocation, had been advised to only use big brushes from the beginning, and he subsequently revealed his remarkable insight in that he'd had the *courage* to do so. His name is Winston Churchill.

As we have seen in all the other cases in this series, there is no set pattern as to where to begin your finish work, but generally it saves time and aggravation if you work from the distance toward the foreground, having first established the darkest foreground accent as a tonal parameter to check other darks against as they lessen in tone and color value toward the distance.

Each time you go out to paint you will find yourself learning simply through trial and error. The more regularly you go the quicker that progress will be. You'll find sometimes that you will surprise yourself, almost by accident attaining a good effect. Each time this happens will give you a signal that pretty well anything is possible if you simply persevere and build your skills one step at a time. Eventually, the biggest kicks you'll get won't come with impressing others, they'll come when you impress yourself.

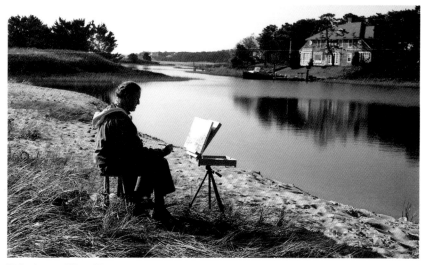

Painting at Hart Haven.

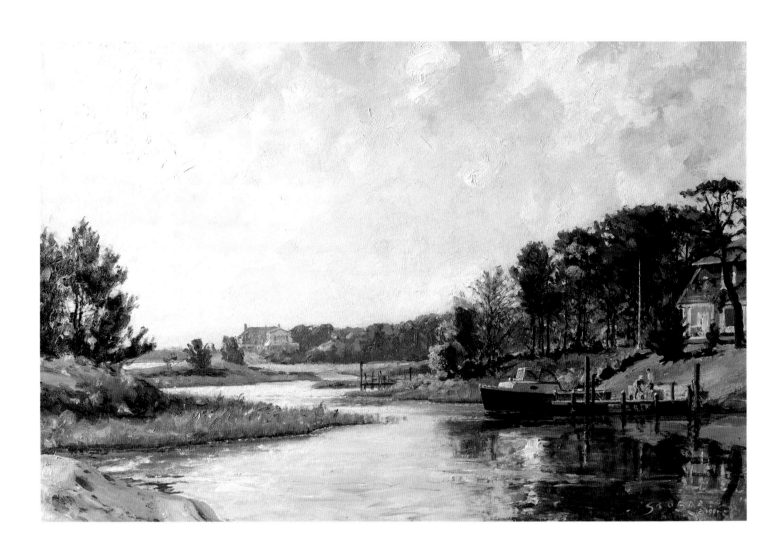

MARTHA'S VINEYARD

Hart Haven.

16 Maui
Hawaii, U.S.A.

The choice of making Maui one of our subjects for this series came quite naturally because I was having a major exhibition of originals there in February 1992.

I had been there two years earlier to complete research for a retrospective painting of Lahaina.

In the mid-nineteenth century Lahaina was a whaling station. Not only did whales abound in the area as they do today, but it was the perfect place for whaling ships to lay in provisions. The crews would refurbish and resupply the vessels and rest and relax after grueling months, perhaps years, in the sub-zero temperatures north of the Bering Strait or in Japan's Okhotsk Sea.

Those were the days when the only oil available for lamps or for lubrication came from the whale, and for that particular painting my choice of viewpoint needed to be offshore as I was anxious to show the panorama of Maui's volcanic peaks as a background. In the foreground I placed several whaling vessels with the whaling brig *Isabella* passing between them, arriving to a welcome of semiclad young women in outrigger canoes.

Apart from the stunning ranges of volcanic peaks and the valleys between them and the excitement of being able to watch whales breaking the ocean's surface from vantage points along the shore, remnants of Maui's historical characteristics are difficult to find. In searching all the traveled areas of the island we found very little that would strike the viewer as definitely "Maui."

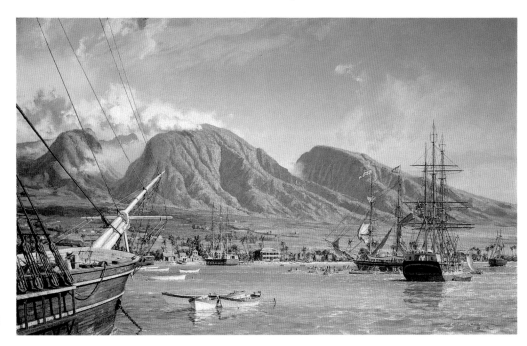

Lahaina: The whaling brig *Isabella* arriving in 1865.

I was looking for an old sugar mill, a farm house, or older Hawaiian-style buildings of unique character, hopefully positioned before the fabulous green-carpeted mountains with valleys disappearing into the clouds as a backdrop. The Kula road looked promising but none in our team were particularly struck by what it had to offer. It was another case of the difficulty of searching for a subject. What really should happen is that the subject finds you. It is that sudden sight—maybe the way the light catches something, or a unique composition that appears before you when you might not even be looking, or a moment in time you instantly want

View from the Kula Road.

to recapture. This is when the magic of finding a good subject happens.

The result was that we decided to go for our final option. The dreaded drive to Hana! Hana is located at the far eastern end of the island, the part of Maui that is dominated by the ten-thousand-foot Mt. Haleakala. The formation of this volcano resulted in innumerable ravines ending at the water's edge. It is such precipitous terrain that gave the road to Hana its reputation as an endurance test: its fifty miles taking some two-and-a-half hours to drive.

Arriving in Hana, we were again at a loss to find a subject that was simple yet impressive, and, more importantly, "Maui." At this point I prevailed on our team to suffer yet more driving, even beyond Hana, which is at the halfway point around the base of the volcanic peak. The road got narrower and rougher, but it was somewhere along this jagged coastline that I'd been told was the place where Charles A. Lindbergh, the famous aviator, had chosen to be buried.

Just finding this spot now became a personal challenge. But how long could I delay our team, already frustrated by our inability to locate a suitable subject, by delving yet farther into this Maui wilderness on a quest that might well not be satisfied?

But in less than half an hour, after stopping a car coming toward us, we learned about the location of the grave site, which Lindbergh had apparently requested should not be indicated in any way.

We soon made a left turn into a washed-out rocky lane, then another left and there before us, through a cluster of banyan trees, stood a charming little white stone church with a red roof, the stone glistening in the morning sun. This was indeed an exciting moment. It was like finding a gold nugget in the sand. In a sense, I could now pay homage to one of my special heroes.

Charles Lindbergh's gravestone.

The small graveyard is in a clearing overlooking the Pacific in a southeasterly direction and has a powerful yet serene presence. The grave, in the shade of a tree, bears the inscription "If I take the wings of the morning and dwell in the uttermost parts of the sea."

Walking toward the cliff's edge and looking back at the scene I saw the mountain through a gap in the trees with the chimney of an old sugar mill in the middle distance. I instantly knew this would be my subject.

In making this decision I consciously had to abandon my idea of painting a simple picture that a young person or beginner would consider possible. The scene was engulfed in a profusion of green foliage of every imaginable variety, and with scarcely enough sky space for a couple of postage stamps. It would be tough. But despite these thoughts our team seemed to share my enthusiasm. We unloaded the gear, set up, and started work.

The Painting

This was obviously a complex subject and I determined from the first brush stroke that I would do all I possibly could to simplify it.

The start was exciting, and establishing the parameters of the view and setting up the composition would, I felt, be easily understood by the viewer. Looking back, as I watch the video in its edited form and note the progress, I'm happiest with it about halfway through. That was before a compulsion to allow detail to intimidate the on-site painter's sacrosanct creed for spontaneous simplicity took over. I began to focus on foliage instead of trees, shingles instead of roof. Even so, I imagine that the majority of viewers will consider this one of the best of the series. Our director said, "The Maui video will be the best!"

In painting this subject, due to the remote location and not wishing to repeat the tortuous drive, we went beyond the two hour window of opportunity. The sun moved to the point where long shadows began to shade the sunlit warmth of the church's painted stonework. This, after all, was the one element that really enlivened the scene, but I soldiered on under the changing conditions.

The greatest proponent of simplification that comes to mind was John Singer Sargent. His economy of brushstroke at times, particularly in his portraits, causes one to almost stare at the work in disbelief. The artist who has a real conviction to reach for these higher standards of finesse can also gain comfort from studying original works by masters such as Constable (small oil sketches), Sorolla, and Seago. The comfort comes from seeing proof that the goals really are attainable. They are attainable of course through a constancy of effort and far less likely through sporadic effort.

The Maui subject was close to being the most difficult of the thirteen paintings to pull off, principally because I was denied the enjoyment of incorporating a substantial sky. Skies are my bailiwick and give me that fulfilling opportunity to tie a composition together come what may. To me, a painting without a major portion of its composition as sky denies the potential for ethereal spaciousness to complement the other features.

While working through this subject, I remember readjusting the church upwards in the composition but in the final analysis felt that this had been a mistake.

After the day was over I decided to restretch the canvas about half an inch lower on the stretcher. This gave the picture the appearance of more height and a fraction more sky which improved the composition and justified my procedure of leaving the tacks proud when initially stretching, thereby allowing this very important option.

An important lesson in this segment of the series is perhaps that of pointing out the fallacy of thinking that if you search long enough you will eventually come across a good subject! Although we got very lucky, this might not necessarily have been so. The subject you should paint is the one you've already been impressed by and have been itching to get to. Artists *never* stop observing and in that sense are much like mice looking for cheese. When they find it they have a compelling instinct to get on with it. It is when inspiration strikes that you should take up the brush, and make the most of it!

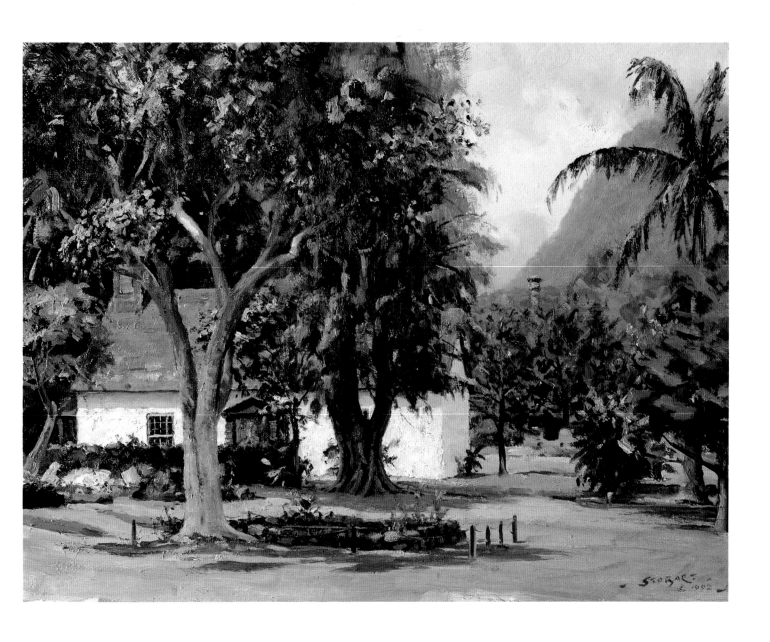

MAUI

The Hoo Mau Paua Paua church beyond Hana.

17 Montserrat
Leeward Islands, West Indies

Initially settled by a group of Irish citizens Montserrat is often called the Emerald Isle of the Caribbean. This island in the West Indies was formed, as in the case of other islands in the Leeward chain, by volcanic action.

Perhaps due to its hilly terrain, Montserrat has not undergone the degree of commercial development that is necessary to attract a growing volume of tourists and therefore has been able to retain an unusual measure of natural charm. Due to its makeup of volcanic rock it has beaches of black sand, but what struck our team and influenced us to go there was its mountain peak and the phenomenon by which clouds form on its windward side and dissipate into small fluffy clouds on its leeward side. This, we felt, would give us a perfect opportunity to concentrate on the subject of skies.

My first visit to the West Indies was to the island of Barbados in 1957. This was the same year that I had emigrated to Canada from England, continuing the practice of completing commissions for shipping company boardrooms.

Having secured temporary accommodation in a McGill University fraternity house as a summer guest, I had befriended a student who persuaded me to invest in my first flight and spend three weeks as his guest at his parents' plantation home. His father managed the sugar plantation at St. Philip. But the big eye-opener for me was the island's colorful port of Georgetown, crowded then with inter-island schooners trading with the other islands. Perhaps the most appealing part of the port was the inner portion where several of the schooners were being careened. They were tilted over so that their undersides could be renovated, first one side and then the other. This was almost like walking back right into the sailing era! This sight, which will always remain etched in my mind, influenced my fascination with reconstructing America's nineteenth-century wharf-side scene, an interest that was to develop some eight years later. In subsequent years I was able to visit many other islands including Jamaica, Martinique, St. Maartens, Trinidad, St. Barths, and Anguilla.

By contrast, Montserrat has no deep water harbor, its commercial port consisting merely of an anchorage offshore below its capital of Plymouth. Supply ships therefore still unload by utilizing their own derricks to transfer their cargoes into barges, which are then towed to the shoreline and unloaded.

The thing that became immediately apparent to us upon our arrival was the friendliness of the people, who seemed delighted to go out of their way if necessary to help us in our discovery of the island.

What I had hoped to find there was an old sugar mill or something of significant character which would identify the island to the viewer of the painting I would be doing, but none of the sugar plantations was still operating. Even the evidence of them would be gone had it not been for the massive stone structures of the early factories that handled the process of extracting the sugar from the cane. The prominent feature of each of these was a substantial tower rather reminiscent of

My oil sketch of the tower on the island's northeast slope.

Colorful island dwellings.

the base of a windmill, which we assumed supplied the driving force for the mills' machinery.

One such structure was high on the windward (northeast) slope of the island with nearly all of its adjacent buildings now all but a pile of rubble. Despite our packed schedule, I couldn't resist doing a quick painting of this, even though there was nothing about the view to typify it as "West Indies." It could have been Ireland, Scotland or even Tristan da Cunha.

We then drove over the entire island searching for a spectacular scene showing instead a typically Montserratean group of dwellings with tin roofs and colorful shutters, ideally with the island's volcanic Chances Peak as a backdrop. Our search, again, was in vain and we ended up returning to the chalet where I was staying, which had a splendid view of the mountain up a long valley. It was the mountain, with its unique cloud formation activity, which had been our initial motivation for choosing Montserrat in the first place.

Other factors that were attractive in this view were the adjacent chalet roofs lining up in such a way as to lead the eye up the valley toward the mountain. In the middle distance backlit trees were creating a perfect sense of brilliant light.

The Painting

Soon after I had started the process of blocking in the scene, a novel idea came into my mind. Just off to my right was the palm-fringed bay and sandy beach, but I noticed that the shape of this was almost identical to the shape of the chalet roof to my near right. The notion struck me that I could swap one for the other, improving the content of the painting considerably. I tried it to see how it would balance out and it worked perfectly. Utilizing this new aspect increased my enthusiasm and I proceeded now with a vengeance to establish the composition and begin handling the various shades of green, lessening in value as they receded all the way up to the mountain itself, which was almost a blue-gray.

With the usual blocking-in process completed I hastened to bring the receding hills to a level of completion before the light, which was moving to my right, changed the painting's backlit nature and began flooding it with side lighting.

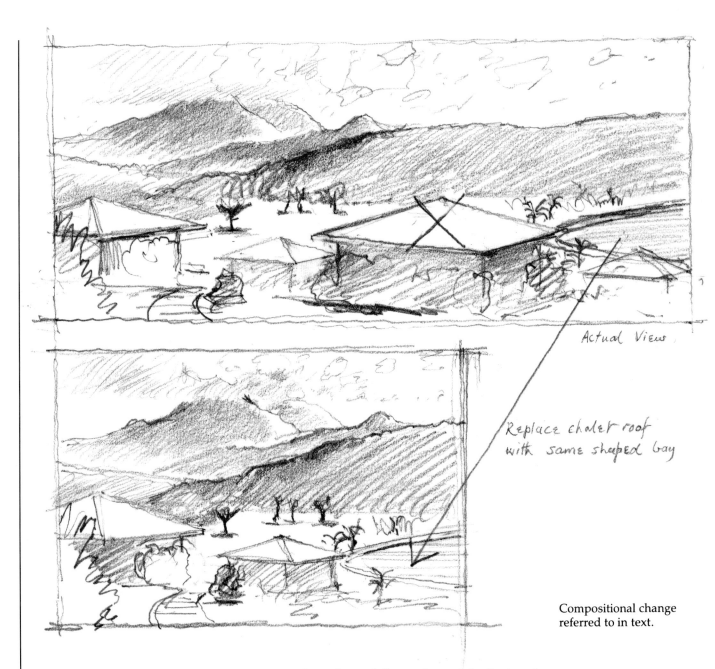

Actual View

Replace chalet roof
with same shaped bay

Compositional change
referred to in text.

Working from the distant mountain toward me I carefully made certain that each
foothill was very slightly denser in tonal value than the one preceding it. In each
case I suggested the groups of buildings as they appeared to me on each hill, with
the principal nearest hill opposite me having five or six major homes, each in a
substantial acreage.

Then came the very attractive trees, silhouetted on the field in the near valley
floor, which I felt gave the whole scene a special charm and made the subject
worthwhile.

Next came the beach and the bay, which had been moved over from my
extreme right. I modified the black sand effect slightly by giving the beach more
light and was soon at the point where I would be working on the chalet roofs.

I had been constantly noticing every change in the cloud formation on the mountain that was to be the major feature of this Montserrat segment, in case anything happened that would oblige me to interrupt work on the foreground to capture a special effect. But the phenomenon of cloud formation was relatively constant throughout the whole time we were filming and I was able to almost complete foreground work before giving total concentration to the sky.

SKIES

It seems that most artists I have become acquainted with have their own specialty. Some element of subject matter—figures, trees, rocks, animals—that they are more comfortable with and that becomes second nature for them to depict. In my case it is the sky. I always have more fun with it, and usually like the sky to be the major part of my paintings. I enjoy making a sky do something major for a painting.

One thing to avoid in painting skies is making them look stormy and foreboding, so my first task here was to be careful to slightly lighten the darkest part of the sky, which was underneath the clouds on the windward (far) side of the mountain where the major buildup was taking place. Another thing to remember is that skies are ethereal and therefore earth colors should be avoided. Colors such as the siennas and ochres would lead to a heavy effect. I use Winsor red, cadmium yellow, permanent green, and French ultramarine and have never needed to augment this range with additional colors for any skies.

The great beauty of outdoor painting is that all the answers are in front of you. Not so with studio work where you must spend limitless time experimenting in order to reach the most appealing solutions by trial and error. With the darkest point of the sky established, I proceeded to complete its lefthand side, which showed warmth in the distance where the buildup was less.

I was feeling very pleased as I had the good fortune to have left the best part to paint last. As I observed the clouds splitting away on the near side I could see that they became immediately fluffy and that the farther they moved away from the mountain peak (which was always in cloud, we never saw the top of it) evaporation became more rapid and not far over to my right they had vanished altogether leaving a clear blue sky.

While this was mere play for me I have to say that when I first painted skies I got pure mud. I know only too well what goes on in the learning curve. But on-site painting of skies is where the speed of your progress will occur. At first you will think "Who on earth talked me into this, this is ridiculous!" If you persevere, however, you will break the barrier and acquire a familiarity with the work that will become pleasurable.

Under more normal circumstances, a plain blue sky has a dome effect. The darker blue is at the top where less atmosphere allows one to look out into clearer space. As the eye moves down toward the horizon the clear blue will get progressively lighter as atmospheric particles become denser as we look along and through them. Then as the sky meets the horizon it merges into the same gray (maybe slightly pinkish) that the distant colors on the land have merged into. This completes the dome effect.

Clouds of course are never pure white, but are well down in tone from white.

Nearer clouds will be yellowish, and again, because of the atmosphere's density, get pinker as they recede finally into the same light gray of the far distance. This effect is termed aerial perspective, which is used to create depth or recession. The whole purpose of the exercise is to give the illusion that you have, in your small painting created a window with a view.

Painting those fluffy clouds breaking off the main mass shrouding the mountain peak was a delight and was wonderful to observe. A significant aspect of the video is that what I am trying to describe here can be seen happening in film. As I completed the painting in Montserrat I applied some pinkish tinges to the distant clouds on the right where they disappeared over the foreground hill, again creating a spatial effect.

This subject, which I had anticipated would be very difficult because of all the greens, turned out to be a real pleasure. You will find that such feelings of personal accomplishment are worth any effort you can muster. I can only hope you'll hang in there and make this exhilarating discovery for yourself!

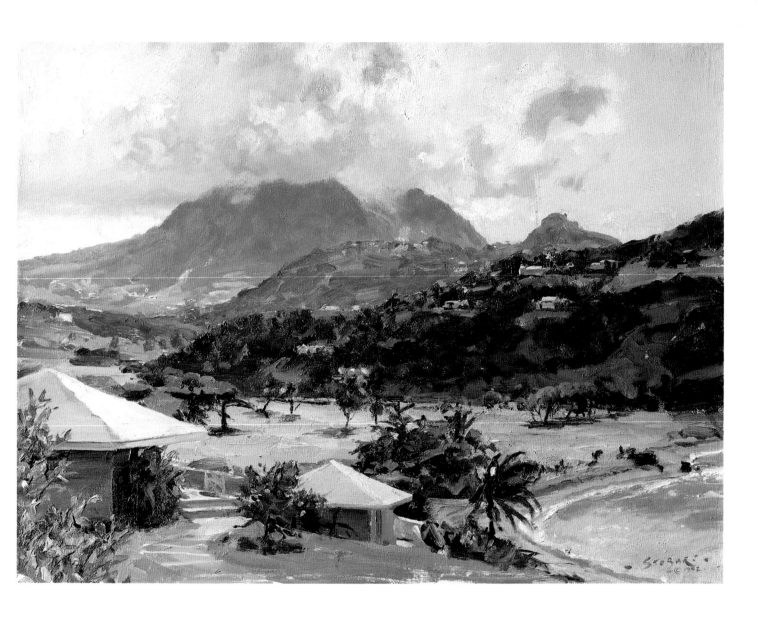

MONTSERRAT

A view of the Island Peaks.

18 Savannah
Georgia, U.S.A.

I might never have had the pleasure of learning about and enjoying the city of Savannah had it not been for Joe de Mers, the noted illustrator who had retired to nearby Hilton Head Island and owned a delightful gallery there in Harbourtown. In 1974 Joe was consultant to the Morris Newspaper Corporation of Savannah. He was then helping them in the formulation of a significant corporate art collection. The corporation's headquarters is located in the historic Sturgess House in Reynolds Square.

In 1818 this building was the base of the Savannah Steamship Corporation. In that year they pioneered a concept for the very first oceangoing steamship. This was to be a sailing ship with a steam engine driving side paddle wheels which folded up from the water when the ship was under sail only.

It seemed most appropriate that a painting of the S.S. *Savannah* leaving the Savannah River on May 20, 1819, for her maiden voyage to Liverpool would make a significant addition to the Morris Newspaper Corporation's collection.

Drawing made from contemporary model of the steamship *Savannah*.

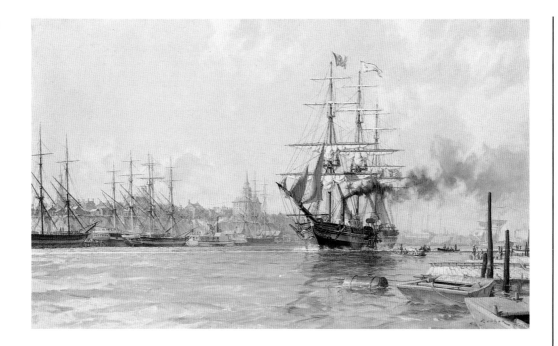

The steamship *Savannah* leaving on her maiden voyage, May 20, 1819.

It was while working in a studio I'd rented in Westport, Connecticut, in 1974 that I was first contacted by Joe de Mers, who came up from Hilton Head to offer me the commission to research and paint the scene. Having already completed my *last* commission, I was lukewarm to the idea, knowing how accepting such obligations can encroach so heavily on one's own ideas of how things should be. That was until I encountered the full brunt of Joe's captivating personality! Joe soon had me convinced that the project would not only be worthwhile, but that the subject might well turn out to be appropriate for a new series of paintings I had my heart set on featuring the rediscovery of America's nineteenth-century wharf-side scene, a subject I discovered had been largely ignored by contemporary artists of the time.

Savannah's primary attraction is, for me, its historic waterfront, pristinely preserved and a great credit to its city fathers. The location has inspired three of my major retrospective studio works, two of which were by moonlight. It was fortunate for me that several old glass-plate negatives showing the area in the mid-nineteenth century have survived and show Savannah's riverfront crowded with sailing ships, several deep at the wharves.

The most unique characteristic of Savannah, however, is the way it was designed by General Oglethorpe along the lines of a grid system he had heard was being utilized in China. The plan reveals a uniform grid that is all commercial, but within each segment of the grid is a square planted with trees and crisscrossed with pathways with residential homes on the outer side of the surrounding street. Access streets join the residential to the commercial areas at eight points around each of the smaller squares.

Each of Savannah's squares focuses on a statute in its center representing a famous person in the city's history. The squares personify Savannah's captivating charm making the city both delightfully walkable and fascinating architecturally with its variety of Spanish, French, and British influence.

Rather than head down to the waterfront for our subject, on this occasion I felt that we should seek an appropriate view of one of the squares that would better epitomize the nature of this delightful southern city that has changed so little over the past two centuries. Riding around in a horse and carriage I was able to get a tour of all the major squares and their variety of buildings, some with grand, curved stone steps, some with columns but most with a distinctly Georgian look with sash windows and inset doorways with polished brass accoutrements.

Suddenly passing through Madison Square, I looked down a long brick pathway to a beige colored building on its far side and made an instant decision to stop right there and start work.

Commercial and residential mix in Savannah's unique city plan.

The Painting

The pathway was speckled with leaves falling from the huge oak trees and the brick of its surface contrasted nicely with the green grass of the square's lawns. The building on the far side, with deep black Georgian-style windows, made an excellent focal point as the perspective of the pathway pointed right to its lefthand side where a set of stone steps led to the entrance on its second floor.

The entire scene was dappled with sunlight filtering through the umbrella of foliage of the tall oaks, draped as they were with a profusion of Spanish moss.

Blocking in this time had to be quick as we had started fairly late in the day. Before too long the sun would be over the trees and behind the buildings on the square's west side.

There were several good points about this composition that made it work well. They included the brick pathway (1) pointing to the focal point of the picture, the lefthand side of the building (2) and the balcony of the building casting a strong shadow over the lower floor (3) creating a spotlight effect. A special feature that I hadn't noticed at first was the shape of a curved wall to the right of the building, which nicely

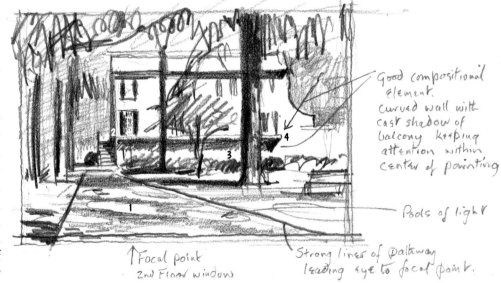

Good compositional element. Curved wall with cast shadow of balcony keeping attention within center of painting

Pools of light

↑ Focal point 2nd Floor window

Strong lines of pathway leading eye to focal point.

106

directed the eye back into the painting via the edge of the shadow of the balcony (4). Finally, the main tree, right of center, conveniently joined the foreground to the middle distance and to the sky.

Of course not having a big sky to play with took away my favorite element, but the subject building gradually took shape and I soon began to realize that the painting was going to work well. Yet again I realized that this was a complex task and hardly the job for a beginner to tackle. The most fun I got out of it was swishing in the patches of light flooding down through the treetops, causing pools of light on the path and lawns and making a pattern on the main tree trunk to the right center.

The whole was completed in about two and a half hours, despite hold-ups. Drawing in all the rest of the trees late in the day and the umbrella of heavy foliage and Spanish moss was done with bold strokes into the now tacky paint of the initial block in. This takes a bit of practice as in a painting like this it is a one-time shot.

If anything, this was a more spontaneous effort than all the others, looser, less finished, more painterly, and left incomplete at the edges. This has a truer nature of an *outdoor* work, which by virtue of the speed with which it needs to be completed, reveals the nature of how it was done, thereby leaving something for the viewer to share and contemplate.

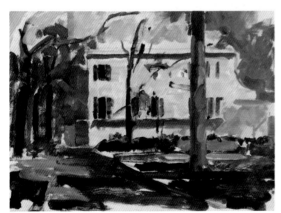

Block-in of Savannah subject.

Working on-site in Madison Square.

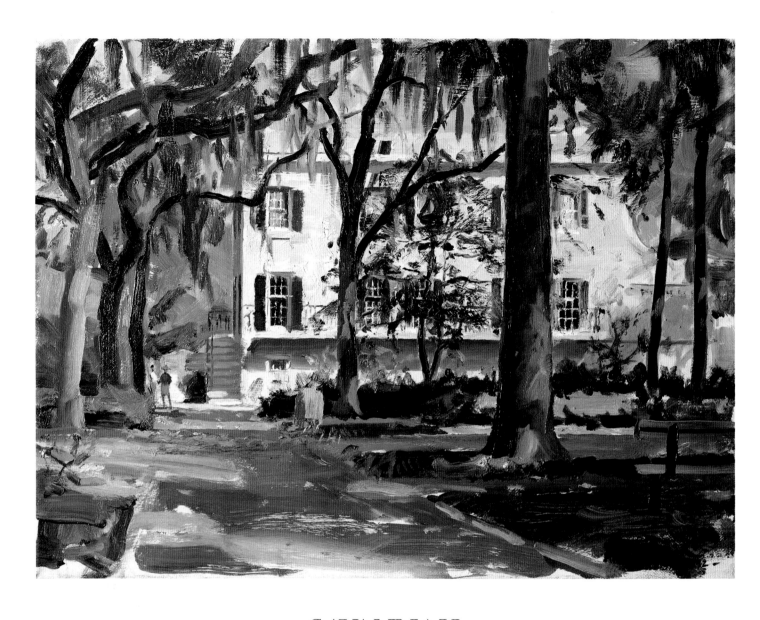

SAVANNAH

Madison Square in the fall.

19 Westport Point
Massachusetts, U.S.A.

When I ponder how it was that I initially came to learn about the Massachusetts–Rhode Island southern shoreline I have to go back to 1956 when I lived in a boarding house called Clydesdale in the London suburb of Earls Court. While there I had befriended an American by the name of Stuart James. As I was already dreaming about emigrating to North America, I found meeting Americans fascinating. I recall long discussions with this new friend who showed me on a map of Massachusetts the shoreline area where his family owned a summer place. I conjured notions that his family must be rich as I'd never had the pleasure of meeting anyone before who talked of having a "summer place."

What the artist will find so fascinating about the peninsula between Fall River (the Sakonnet River) and New Bedford (the Acushnet River) is its unspoiled rural charm. There seems to be a community code in that area that is accomplishing the ideal of preventing piecemeal development of shoreline property. The result is that there are still open vistas over the major estuaries and aspects of both branches of the Westport River, that viewed over undulating open farmland are scarcely changed since Childe Hassam and Worthington Whitteridge were inspired to paint its beauty seventy-five years ago.

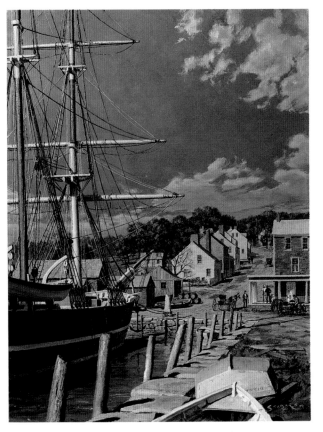

The whaling brig *Kate Cory* at Westport Point in 1858.

It was some twenty years ago that the curator of the nearby New Bedford Whaling Museum had tried to persuade me to produce a painting of a whaling ship called the *Kate Cory*. The home base of this vessel in the late nineteenth century was the charming little inland port of Westport Point and I was given a royal tour of the entire area in order to view the Point from all conceivable aspects. A superb model of the vessel had been created for the museum and to further the public's interest in the historic whaling brig it was hoped that I would be inspired to do a special painting. I now find it embarrassing to confess that I was consumed with painting America's major ports at that time and never got around to painting the *Kate Cory* until twenty years later. Today a fishing port, this inland harbor lies at the confluence of the east and west branches of the Westport River, totally protected from the ocean's moods by the long peninsula of Horseneck Beach.

The attraction of Westport Point to the artist is that its only street, Main Street, is lined with historic homes of great character, mostly finished in shingle or white clapboard. It is among the views between these homes,

each looking out over the Westport River, that I found such an ideal subject to demonstrate simple perspective. In no time I had selected my view, the dazzling white quahog driveway at the lower end of the street beside the Issaac Cory house. It was the white painted barn behind the house that would be my focal point, the driveway itself pointing to the Westport River and beyond. The most appealing factor about this view was the simplicity of the shapes, each clearly defined by its own local color. The white driveway flanked by green verges, the white barn, and the tree to the left were silhouetted against the blues of the sky and water. I was soon to learn from the present owner, Owen Dexter, that this had been the home of the master of the whaling brig *Kate Cory*. The brig had a short, if colorful life. Having been registered in Westport in 1858, she was burned following her capture during the Civil War by the Confederate raider *Alabama* in 1863.

The Painting

In deciding the parameters of my composition I felt it important to keep the left-hand tree with the picket fence before it, nicely pointing to the distant view. At the top right I wanted to keep the barn's cupola and resolve the righthand edge by keeping part of the main house in the view.

The next decision to make was the placement of the horizon line. In all beginnings this is a point of no return. In setting this slightly below midway down the 12″ × 16″ canvas, I quickly sketched in the main compositional points to be sure they would balance out nicely in the format. It is important to always avoid midway measures or placing any significant item in the center of a gap or having two features of similar size opposing each other in a composition. In my student days I recall being informed that this presented an "unresolved duality." It did occur to me later, however, that some artists would have chosen a horizon line *above* the midway point in the format. This would also have worked well as it would have given more space for and attention to the white driveway.

As I tried to make things look simple, to encourage beginners to try something similar, the shadow of the eaves on the nearside of the barn lengthened with every brush stroke I made, forcing me to make a major decision. Would I have that side of the barn in light or in shadow? I decided to keep the area in the light, but to show a lengthening shadow. Shadows create a sense of light and I liked the way the edge of the barn's side window frame was catching the sun's rays, an added opportunity to give the all-important illusion of light.

This is what painting is all about. As my first teacher Alfred Bladen told us, "Painting is a matter of trial and error." Continuous changes outdoors give the artist a wide variety of choices. It is along the pathway of selecting these options that your creative ability will thrive.

PERSPECTIVE

To explain the basic fundamentals of *lineal* perspective I have drawn the accompanying three diagrams.

1. This view, looking at the corner of a building, employs two vanishing points in a simplified example. In more complex views showing curved streets or a jumble of buildings or objects in differing planes there could be numerous vanishing points.

2. Our Westport scene, showing the horizon line (which is always at eye level) and the lineal perspective lines against which one can easily correct one's own drawing for accuracy.

All lines relative to the sides of buildings facing the driveway converge at one vanishing point (see blue lines). Perspective lines relative to the driveway itself and

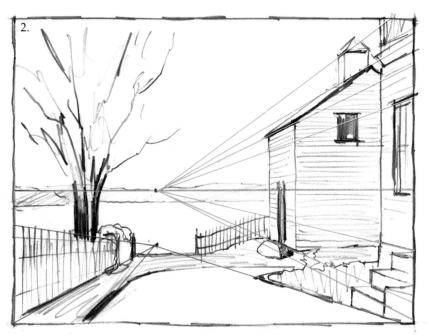

the picket fence, because they are sloping down toward the near shore, converge at a point *below* the horizon line (see red lines).

3. In looking directly down a street this shows the use of *parallel* perspective. The rule here is that the cone of vision from the viewpoint should not exceed 60 degrees, otherwise distortion will be apparent to the viewer. As you see from the sketch, all lines at 90 degrees to the direction you are looking, in this case are parallel. Parallel perspective utilizes *one* vanishing point. The barn and house in the Westport Point subject are structured in parallel perspective. Lines relative to the near side of the barn have no vanishing point to the right. The righthand edge of our *cone of vision* is within a total 60 degree angle for the width of the entire subject.

The final element I want to mention in this brief discussion on perspective is *aerial* perspective. This concerns tonal and color changes as objects recede into the distance. For instance, if a bright red car was ten feet away from you in full sunlight its color and value would be bright and strong. At a distance of one mile its color would be substantially toned down in its brightness, its

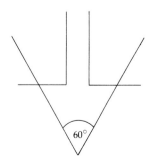

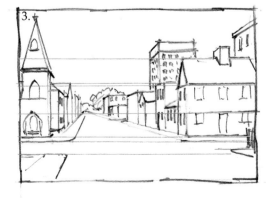

111

real color having been obscured by the atmosphere that will now be between you and the vehicle. At five miles distance the color of the car, in normal circumstances, because of the density of the lower atmosphere would begin to merge into the warm grayish hue of everything else at a far distance. Aerial perspective is therefore the key to creating the illusion of space. The darkest elements and the brightest elements in an outside view will all merge into a gray in the far distance.

As I sat there painting at Westport Point a breeze we had been told about that would increase at my back as the sun got higher made me grateful that I'd brought along a hooded jacket. For me, just the slightest draft, if persistent, can cause aggravating discomfort.

Even with high enthusiasm, you can never predict how a painting will go. I was convinced that this painting would be an easy exercise, yet it proved more complex than it appeared at first. As I prevailed with it, I hoped all day long that a big ketch would suddenly appear entering the harbor. If I could paint it in from life, what an ending this would make for the show! But it wasn't until I was packing up my gear that a tall mast appeared in the far distance passing the Knubble. A vessel was entering port! All I could do at that point was to make a quick pencil sketch of it and reach a decision later as to whether I would insert it into the painting.

Several things went extremely well. I especially enjoyed putting in the lefthand tree and the effect I got with the grass verge. But as you progress with your own efforts you will find out, just as I did, that some things you *think* are going to be easy will turn out to be difficult, and vice versa. But one thing is for sure. If you stick with it, at some point you are going to impress yourself. That will be only the beginning of the fun in it.

Progressing with blocking in

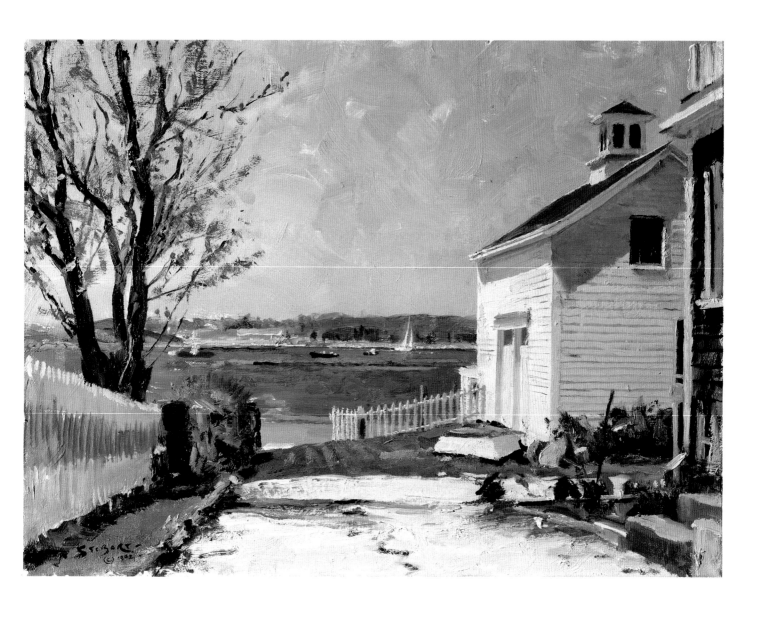

WESTPORT POINT

A view looking west over the Westport River.

Acknowledgements

I feel deeply indebted to the artists who so generously contributed their time and expertise to help widen the appeal of both the book and the TV series, introducing to TV viewers and our readers alike the uniqueness inherent in individual styles. Noted watercolorist Bert Wright and oil painter Trevor Chamberlain both did a magnificent job. Portrait painter Joe Bowler also gave us wonderful insight into his ways of working on our visit to his studio in Hilton Head Island.

Special thanks also go to Cordy Lougheed for locating the photo of her late husband demonstrating his use of a simple metal plate under his paint box utilising a camera tripod.

My appreciation goes out to gifted artist Michael Karas of Maine who has inspired me and many other outdoor painters by his early maturity with the craft.

My gratitude also goes to those British museums that have allowed us to illustrate the works of Constable: The Victoria and Albert Museum, London, and the National Gallery, London; and to the Musée des Beaux Arts, Reims, France, for permission to illustrate the work of Corot. My deep thanks also goes to the Coe Kerr Gallery, New York, who so generously made it possible for us to include a work by Edward Seago in this book.

But without the tireless dedication of Sandra Heaphy, who so expertly manages our expanding endeavors, who endured my entry into the laptop world, and was always at the ready to record the progress of the paintings, this book would simply not have been possible.

My praise also goes to all those others who have inspired and encouraged me to champion the cause of seeking to help the aspiring artist in the face of many adverse influences, encouraging them to persevere and keep alive the art of painting from nature, which may well surprise us all by producing even greater talent in the future than has ever been seen before.

Finally, my sincere thanks go to editor Theresa Craig for Americanizing my English, to Stanley Drate for a characterful design, and to Dave Zable whose expertise in production resulted in such a satisfying result. All their efforts have been most sincerely appreciated.

All illustrations of John Stobart studio paintings courtesy of Maritime Heritage Prints, Boston.